HOW TO
CREATE LIGHT
IN YOUR PAINTINGS

THE ARTIST'S GUIDE TO USING TONE EFFECTIVELY

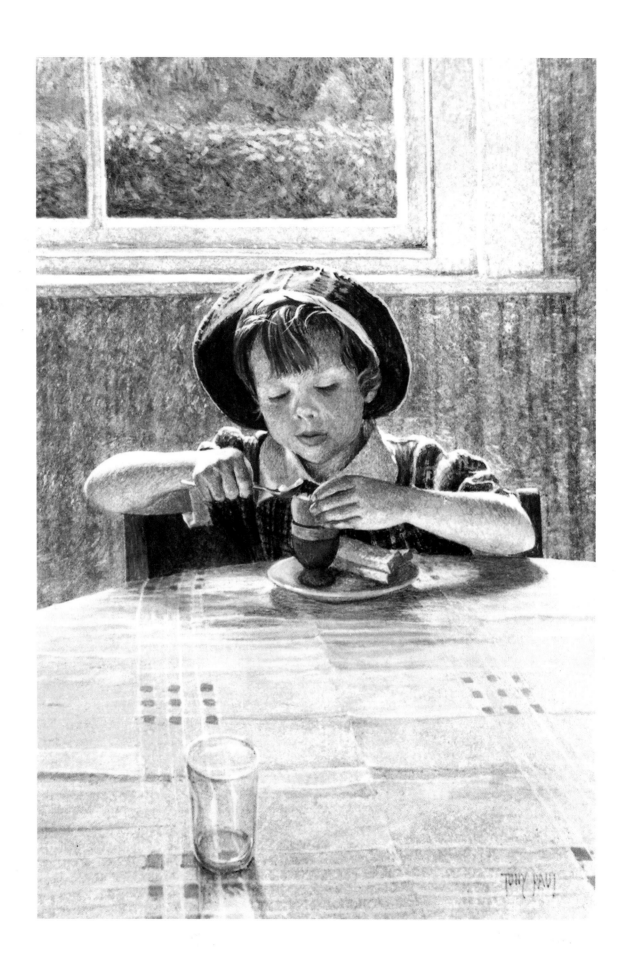

HOW TO
CREATE LIGHT
IN YOUR PAINTINGS

THE ARTIST'S GUIDE TO USING TONE EFFECTIVELY

TONY PAUL

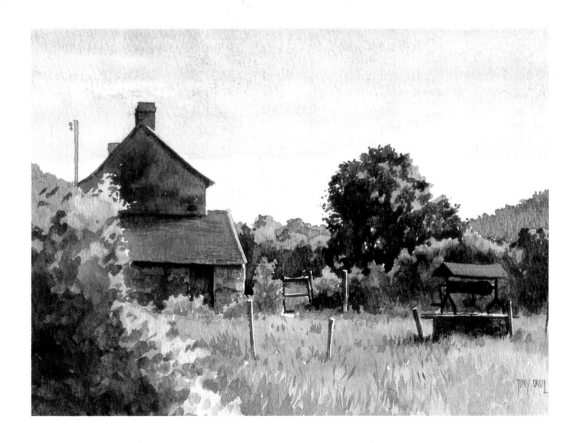

NEW
HOLLAND

Published in 2004 by
New Holland Publishers (UK) Ltd
London • Cape Town • Sydney • Auckland

Garfield House
86–88 Edgware Road
London W2 2EA
United Kingdom
www.newhollandpublishers.com

80 McKenzie Street
Cape Town 8001
South Africa

14 Aquatic Drive
Frenchs Forest, NSW 2086
Australia

218 Lake Road
Northcote, Auckland
New Zealand

ISBN 1 84330 707 3

Senior Editor: Clare Hubbard
Editor: Anna Southgate
Designer: Ian Sandom
Production: Hazel Kirkman
Editorial Direction: Rosemary Wilkinson

2 4 6 8 10 9 7 5 3 1

Reproduction by Modern Age Repro House Ltd, Hong Kong
Printed and bound by Times Offset (M) Sdn. Bhd., Malaysia

Captions
Page 2: The Breakfast Egg; *egg tempera; 300 x 190mm (12 x 8in); by Tony Paul.*
Page 3: Chenonceau Farmhouse; *watercolour; 280 x 205mm (11 x 8in); by Tony Paul.*

CONTENTS

Pages 41 and 42 missing

FOREWORD

I first met Tony Paul a little over six years ago, although I had known of his existence prior to that through his articles in *Leisure Painter* magazine.

I was, and still am, impressed by Tony's breadth of knowledge and understanding of painting, past and present. He has a style of writing that engages you in such a way that you believe you are being reminded of something you already know.

It was only a matter of time before I asked Tony to tutor some painting courses for us in Norfolk and, very kindly, he agreed. Six years later, I am delighted to say that he continues to do so and, what started as a purely professional association has developed into a friendship that I value very highly indeed.

I distinctly remember discussing how to incorporate his, then new, course into our existing programme. I asked what he would like the content of the course to be and whether this could be conveyed easily in the title. The reply was, as ever, straightforward and to the point: "I think we should call it 'Capturing Light in Your Paintings' because that is really what it's all about"... I couldn't have put it better myself!

Richard Cartwright
West Norfolk Arts Centre

RIGHT The Shell-seekers – Evening Light, Poole Harbour; *egg tempera; 300 x 190mm (12 x 7½in); by Tony Paul.*

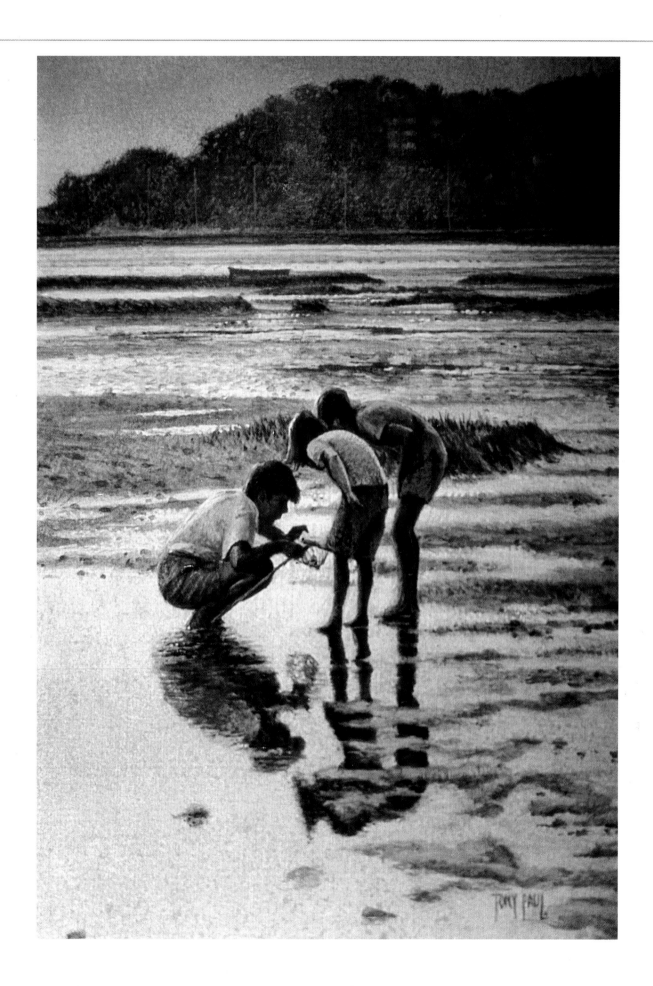

INTRODUCTION

Picasso once said, "There are artists who transform the sun into a yellow spot, but there are others who transform a yellow spot into the sun." There is something almost magical in the work of the latter type of painter, who has such understanding and control of tone that light does actually appear to be coming from the painting. Thomas Eakins, talking about light, called it "the big tool" and, for the naturalistic painter, there is surely no more useful device. Not only does it give form to the components of our world but it can also add beauty, tranquillity, mystery, drama, delicacy and tension. For me, much of the emotion in a painting is achieved through the sensitive use of light in the subject. Without its effects, paintings often look flat and bland, clearly with something lacking.

An interesting fall of light has always been a primary consideration in my own paintings, and in this book I have chosen to include the work of a number of remarkable painters who share this fascination. Here you will find a structured course on the understanding and practice of tonal control – a course that I hope you will find enjoyable as well as instructive.

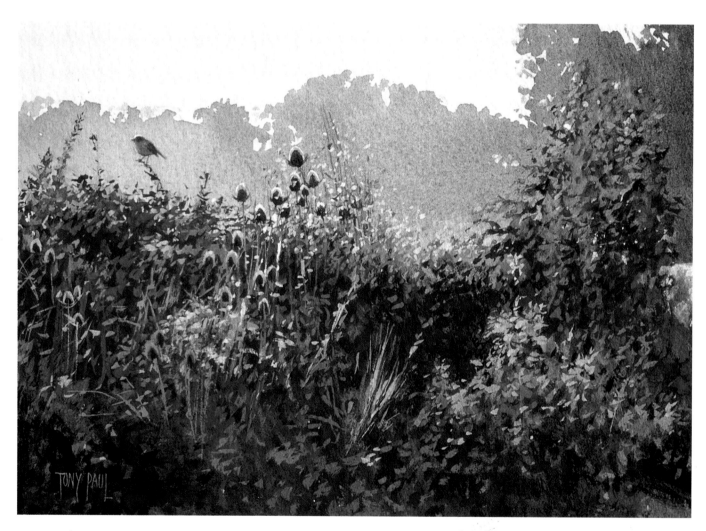

ABOVE Robin at Kingcombe; *watercolour; 280 x 380mm (11 x 15in); by Tony Paul.*

PART ONE
WHAT IS LIGHT AND
HOW DOES IT WORK?

ABOVE Waiting for the Postman;
egg tempera; 178 x 152mm (7 x 6in); by Tony Paul.

THE EYE AND LIGHT

Figure 1

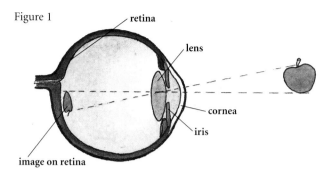

retina
lens
cornea
iris
image on retina

Figure 2

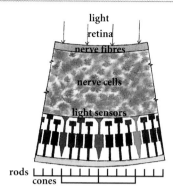

light
retina
nerve fibres
nerve cells
light sensors
rods
cones

Light enters the eye via the transparent cornea, then through a hole in the iris – the pupil. The muscles of the iris open or close the pupil in order to regulate the amount of light entering the eye. Light then passes through the lens and an upside-down image is projected onto the retina at the back of the eye. (Figure 1.)

The retina is composed of layers of blood vessels, nerve fibres, supporting cells and millions of microscopic, light-sensitive receptors, known because of their shapes, as rods and cones. These receptors convert light into electrical impulses, which are then processed by the brain into comprehensible images. (Figure 2.)

The rods and cones have distinctly different functions.

The rods come into play under low light conditions, outnumbering the cones by three to one, and see in tone, rather than colour. The cones, on the other hand, work in daylight to give us colour vision. There are three different cone types: one that is sensitive to red, one to green and one to blue.

In fairly dark conditions the colour-seeing cones are ineffective and we rely on the tonal rods to see enough to be aware of our surroundings, with the world appearing largely in black, white and shades of grey. Conversely, during a bright sunny day the rods take a back seat, while the cones register this wonderful world of ours in full and glorious colour.

LIGHT AS COLOUR

Figure 3

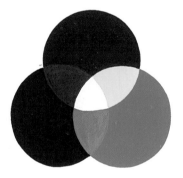

Figure 4

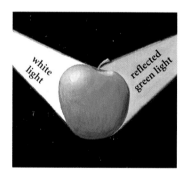

white light
reflected green light

In many ways light is similar to sound. As sound is divided into frequencies in terms of cycles per second – the fewer cycles the lower the sound – similarly, light is sent in frequency waves. Our eyes see these as distinct colours mixed from the cones' palette of red, green and blue. All these lights combine to make white light – the light that comes from the sun.

If you look at the diagram of light (Figure 3) you can see the three colours picked up by the cone receptors. When the green and red lights are mixed you get yellow, when the violet/blue mixes with the red you get a shade of magenta, and when green and blue mix you have a

colour that is known as cyan. You will note that, when one light is added to another, the mix is lighter than either of its components. When all three coloured lights are combined you get white light. (Figure 3.)

When light strikes a surface, some of it is absorbed by the object while the rest is reflected, and it is the reflected light that we see. Take, for instance, a green apple – light strikes its surface and wavelengths of all colours except green are absorbed. This is why we see it as green. You will note from the apple illustrated (Figure 4) that, as less light strikes the surface, such as in shadow areas, the colour of the green is less intense, as well as darker.

Generally speaking, the brighter and more directly the light falls on an object the more intense the colour will appear. If you look out of the window on a dull day the colours will appear more muted. Should the sun break through suddenly and light up the scene, it is almost as if a grey veil has been lifted, colours glow.

Naturally pale objects will reflect more light than darker ones – for instance a pink object will reflect more light than one of a deep crimson, even though only red light is involved.

Pure white will reflect almost all light. This is why white objects in full sun can be almost unbearable to look at. Black objects, on the other hand, absorb almost all light waves, which are turned into heat energy in the process. What little light is reflected enables us to see the form of the object.

It has to be said that what I have given you is a simplistic view of light reflection. In practice – for example the green apple – hints of other colours such as yellows, reds or blues, will be reflected, modifying the green to warmer and cooler hues. Natural objects are rarely totally one colour.

Full Sun

This beach scene is full of light. The colours of the windbreaks and the red bucket are bright in hue, with strongly saturated colours, because the sun is shining through them. The tones of the figures, particularly those that are close to the water, are dark against the shimmering light of the sea.

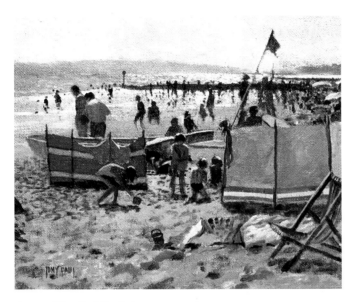

ABOVE The Red Bucket;
oil; 229 x 305mm (9 x 12in); by Tony Paul.

Dusky Light

The power has gone from the sun and it casts a warm glow over the landscape. Even the distant hills have a peachy tint. The greens – which in daylight would be vibrant and varied – are now subdued and broadly similar. As the light continues to fade, the greens will darken and become even more grey.

ABOVE Bonfires at the Allotments;
oil; 457 x 660mm (18 x 26in); by Tony Paul.

PART TWO
INTERPRETING LIGHT INTO A
STRUCTURE OF TONAL VALUES

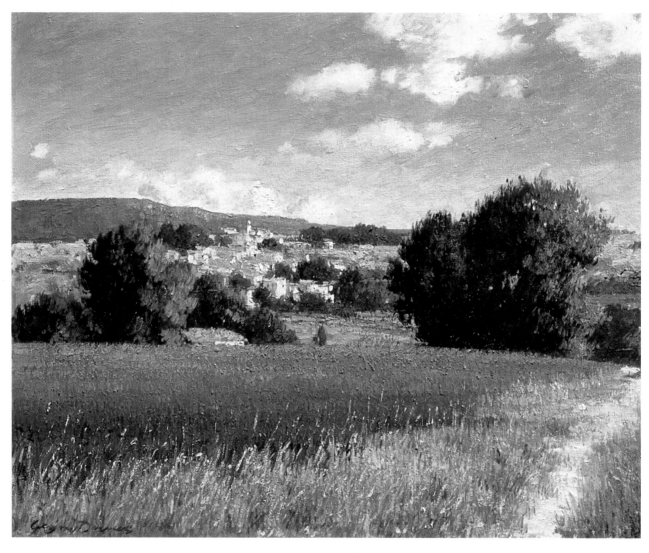

ABOVE Lavender Fields, France;
oil; 510 x 610mm (20 x 24in); by Gregory Davies.

PAINTING WITH LIGHT

The fresh, clear air of southern France is captured in the oil painting *Lavender Fields* by Gregory Davies (see left). The full-summer, early-evening light, saturated and with a yellowish tinge lights the scene. See how carefully the tones have been controlled to help the painting's elements read against one another. If you look at the tree on the right, the orangey right-hand side stands out against the lower dark tone and the upper buff colour. The shadowed side reads clearly against the lighter landscape beyond. The violet/mauve slash of lavender is a perfect foil to the warm yellows, ochres and greens elsewhere and may have been too strong had the artist not provided a duller echo in the background hills. I love the way the violet of the lavender has found darker echoes in the shadows in the trees.

There are very few art forms that actually use light to create an image. Perhaps the most obvious one is the historic medium of stained glass. It is not difficult to imagine the impact that windows such as these had upon the impoverished people who worked the land in times gone by. Accustomed to the day-to-day world of drab earth colours, the experience of seeing the rich, vibrant glass projected into multi-coloured beams of light and falling as rainbow shapes upon the dimly lit church floor must have filled churchgoers with a genuine sense of awe. But, of course, without the light shining through the glass there would be no readable image. It simply would not work.

An example of a modern art form is the photographic image. The slides made for the illustrations in this book, for example, had a similar reliance on light to make them work. Television, the computer screen and, of course, the moving pictures of the cinema all rely on the powerful beam of the projector to create images. They all use actual light, but the painter cannot go down to his local art store and buy a tube of light: it has to be represented by pigments.

Light as Pigment

Pigments cannot match the range of tones found in light. They cannot achieve anything like the blinding light of the sun, the glare of the sparkle on water or the deep, inky dark of an unlit cellar. In fact, pigments can only capture about 40 per cent of that range, with the greatest loss at the light end of the scale. Our white pigments, pure as they are, are dull substitutes for nature's bright lights, but they are the best that we have.

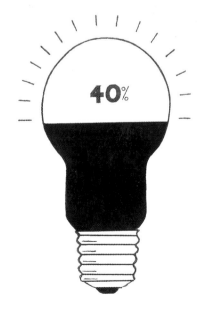

TONAL RELATIONSHIPS

As we cannot create light with our pigments we have to represent it. Take a simple subject such as this little Chinese bowl (Figure 1). If I paint it in its actual tone it is virtually white. The highlights that tell us the bowl has a highly reflective surface simply do not read, because white pigment cannot reproduce the strength of real light, and is too similar to the tone of the bowl. If I want the glaze to read as it should I have to tone down (darken) the bowl's colour until the white – applied as the light on the rim and inner surface – reads as this reflected light (Figure 2). Because every other element in the painting has been toned down it looks right.

Figure 1

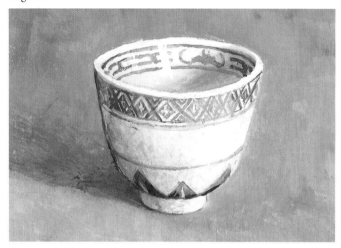

Figure 2

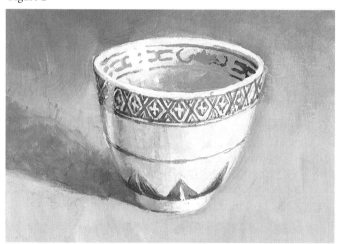

Similarly, if I wish to show a blinding light on water, I have to step down the tones of all the other elements in the painting so that the white reads as this blinding light. Figure 3 shows a simple seascape sketch that has been painted using colours of a natural tone. I have put in the sparkle of light on the water but it barely reads against the sea, let alone shows its brilliance. Mere white paint just cannot achieve that brightness. I could pile it on forever but it would never read as sparkle. In Figure 4 I have darkened the whole subject so the white paint effectively reads as sparkling light. It is sometimes difficult to know just how much to darken the tones. The darker the subject is painted, the brighter the light will appear to be, but, in a daylight subject, if it is made too dark it could look like a twilight or night scene, so it is best to darken the subject only enough to achieve the sparkling effect.

Figure 3

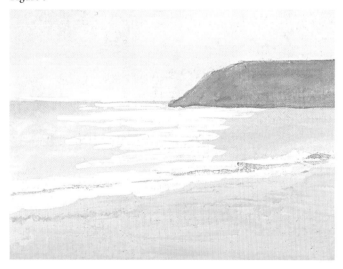

Figure 4

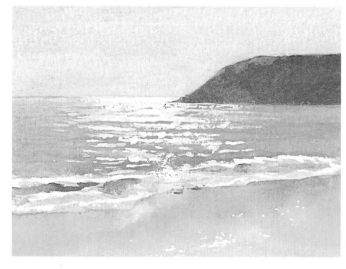

TONAL DRAWING

Using Four Tones

Whenever we look at a subject, if we observe it carefully enough we can see many different tones. In some subjects the contrasts between them may be quite distinct, while in others they may be rather close.

As with all painting, simplification is often necessary in order to convey the essence of the subject strongly, while avoiding a fussy and confused effect. Some tutors recommend simplifying the tones in a work to three – a light, a mid-tone and a dark. I think that although this can work well enough in strongly tonal subjects, in less contrasted subjects it can appear too stark. Reducing the number of tones in a drawing (or painting) to four, however, will minimize the chance of confusion while maintaining the work's clarity and strength.

The four tones are a light, a half-light, a half-dark and a dark. As you can see from the tonal scale (see left) the tones are quite distinct and read well against one another.

Using these four tones I made the drawing below. See how they work against one another to give a sense of form to the subject. The dark of his hair stands out against the half-light of the background wall, while the light of his left shoulder tells against the half-dark of the speaker cabinet. The background – the walls hung with guitars – has been drawn using lights, half-lights and half-darks. See how the light from the top left gives form to Mark's head: his face, looking down at his left hand, is in shadow, with half-lights on his forehead, half-darks on his lower face.

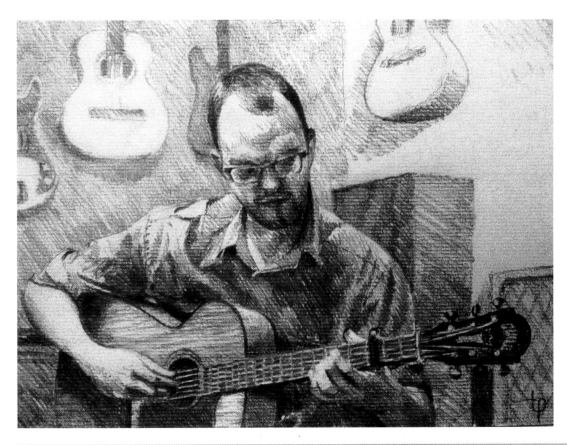

LEFT Mark;
pencil;
152 x 203mm
(6 x 7¾in);
by Tony Paul.

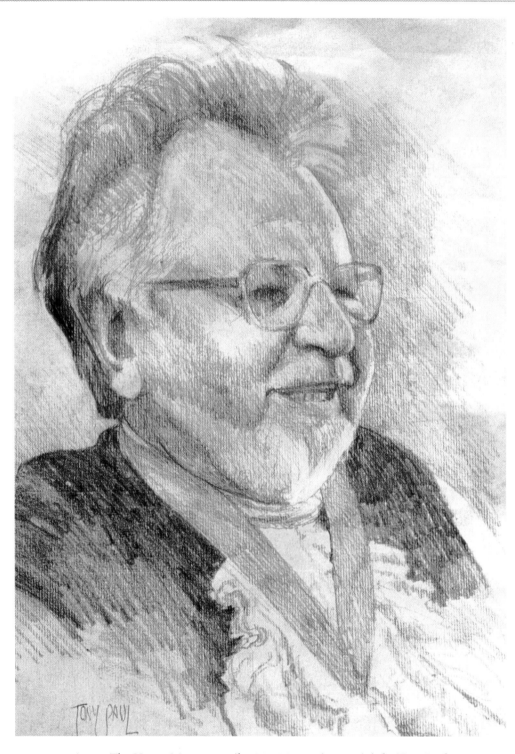

ABOVE The Happy Mayor; *pencil; 406 x 304mm (16 x 12in); by Tony Paul.*

The local Mayor visited my portrait class and sat for us in his scarlet, sable-collared robe. He wasn't static but talked with us in a light-hearted way for most of the time, allowing us to capture his smile. The light was coming strongly on to the side of his face. To capture this effect I shaded the paper outside his face so that its edge was white. See how the use of four tones has adequately modelled his features – the half-light of the majority of his face tells against the half-darks of his near cheek. All four tones were needed to draw his nose.

PENCIL

The humble pencil is an excellent medium with which to practise tonal drawing. Its "lead" is made from clay and graphite in various degrees of hardness and blackness. HB is the central grade – a lead of medium hardness with an averagely black mark. HB pencils are often used for writing because the marks they make are adequately dark while retaining their point for a fairly long time without needing to be sharpened. From this central grade the pencils deviate in grades of hardness (H) or blackness (B). The higher the number in front of the H or B, the greater the hardness or blackness respectively.

A 6H pencil, for example, will make a pale-greyish line but will be hard enough almost to cut the paper. A 6B pencil, on the other hand, will give a densely black mark that smudges easily but will need to be sharpened frequently.

Most artists favour the blacker range of pencils, perhaps using a combination of pencils in one drawing, choosing a different grade for each tone. I favour the 2B, myself, particularly when working on a smallish scale. It makes a true, black mark that doesn't smudge too readily while retaining a reasonably good point.

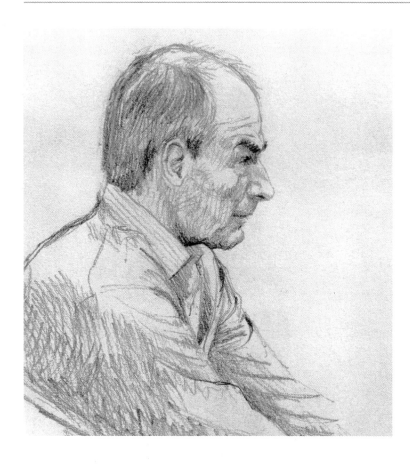

This drawing of Richard was made in about a quarter of an hour in my sketchbook. I drew him carefully and used the point of the pencil to apply the shading to indicate volume in the form. There are two strong darks – the eyebrows and under the chin, with half-darks in the hair and in the front of the jumper. Half-lights model the structures in the face and sleeves of the jumper, while the lights are left as white paper.

LEFT Richard;
pencil; 280 x 205mm (11 x 8in); by Tony Paul.

In this simple still life, darks were put in densely at the foot and rim of the jug. The remaining tones are half-darks and half-lights drawn in using the side of the pencil, allowing the texture of the paper to give character to the marks. Again, the lights were left as plain paper, which in this case was a soft cream colour.

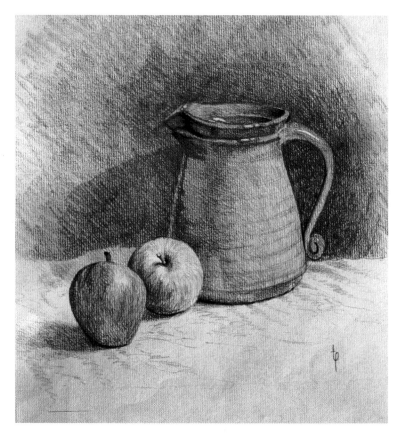

RIGHT A Simple Still Life;
pencil; 280 x 205mm (11 x 8in); by Tony Paul.

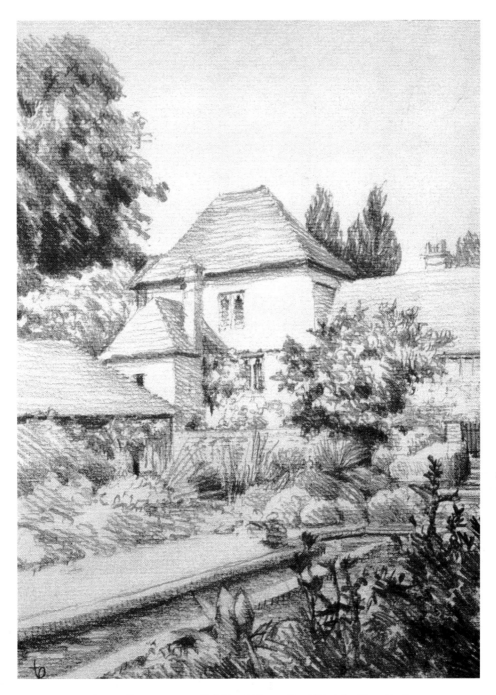

ABOVE Rymans; *pencil; 203 x 132mm (8 x 5¼in); by Tony Paul.*

In a complex subject such as *Rymans* (a house and garden in West Sussex), simplification and organization have to be the prime considerations. Again I have used the four tones – lights, half-lights, half-darks and darks to help the image read. The subject was full of detail but I didn't want to let that distract me, preferring to let the tonal drawing and only a little sharp definition tell the story. I began at the back, with the house and trees, the different tones giving the building a solid appearance.

The garden had to be simplified. It was a riot of colour and texture, but would have been far too complex to read well so, taking the major elements that worked against one another, I drew an approximation of what was there, making sure that tone stood out against tone and that the direction of light was consistent. Lastly I treated the foreground foliage, which just breaks the near edge of the formal pond, as being largely in silhouette in order to pull it clearly into the foreground.

CHARCOAL

One of the earliest means of making a mark, charcoal is still an excellent and popular drawing medium. When I was at art college I hated using it, finding it messy and imprecise. Some 30 years later I rediscovered it and, much to my surprise, found that I loved working with it. I enjoyed its sensitivity and the ease with which it could capture light and slight nuances of tone. Reluctantly I came to the conclusion that it was me, rather than the charcoal, that had been messy and imprecise.

When sharpened, a stick of charcoal is capable of fine detail, and yet it is generally used as a broad tonal medium. It gives a strong, black line that has a soft, silky texture, and if a thick stick is used on its side it can create wide sweeps of tone. It is wise to use paper with a good surface grain, or "tooth", for charcoal work. If the paper is too smooth the charcoal will be difficult to use, often just skidding across, leaving little or no mark, and results will be disappointing.

Charcoal is particularly good for life drawing (drawing from the nude model) where its speed and ease of use in the blending and manipulation of tones are useful characteristics.

Drawing errors can be brushed off or rubbed out easily – a putty rubber is ideal for this. When a drawing is complete its surface can easily be damaged – the slightest touch will smudge the image or alter a tone and could ruin the work – so many artists spray their drawings with fixative. An oil painter will often work out a drawing first on canvas in charcoal. The lines can be dusted off, leaving the ghost of the image, and will have no effect on the colour that is subsequently applied.

The sketch of Lynsey and Molly (shown right) was drawn one afternoon when Lynsey was waiting to be picked up to go to a party. This image was too good to miss but I had to work quickly and so concentrated on just her figure and the dog. Molly's pale coat has been brought out by darkening the sofa immediately behind her, modelling the rounded shapes of the cushions with dark and half-dark tones. The light edge of the back cushion was left as cream paper against the half-dark tone of the wall behind.

The white window frame is in shadow and is, therefore, a half-light – the lightest tone being reserved for the light on the window sill and outside. Twenty minutes later the doorbell rang and daughter and dog flew to answer it. I finished working on the sofa and the rest of the setting without them.

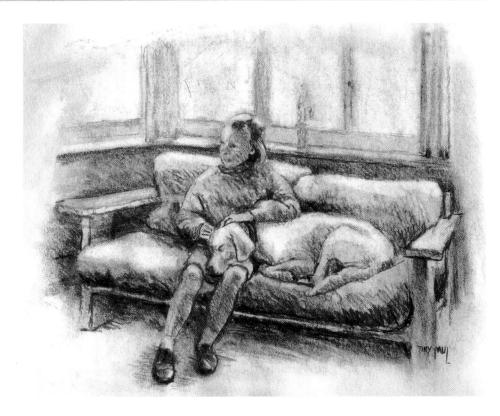

RIGHT Lynsey and Molly; *charcoal; 386 x 508mm (15¼ x 20in); by Tony Paul.*

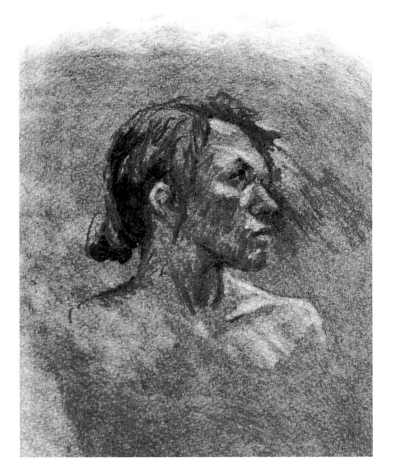

This sketch was made using a technique called the "rub-out" technique. It involves covering the paper in a layer of charcoal, then rubbing it into the surface with a rag or kitchen roll. This provides a smooth half-light tone on which to work. A putty rubber is then used to lift out the lights, while darker tones are added by drawing with more charcoal. In this quick sketch, which took about five minutes, the four tones are visible immediately.

LEFT The Head of a Life Model; *charcoal; 250 x 200mm (10 x 7¾in); by Tony Paul.*

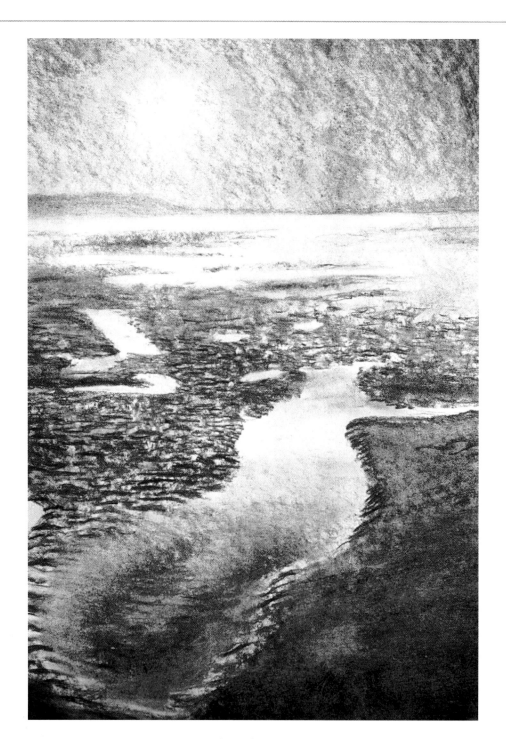

ABOVE Poole Harbour – Low Tide;
charcoal; 508 x 406mm (20 x 16in); by Tony Paul.

I used quite a coarse paper for the study of *Poole Harbour – Low Tide*. I was interested in the way that the evening light was working on the rippled sand, and in the way the beach had been sculpted by bait diggers. I also tried to capture a feeling of the depth of the water in the foreground pool. However, the most striking thing about the subject was the strong light on the water, emphasized by the half-light of the sky and the darker tones of the rippled sand. Certain areas were blended into the paper with a finger and overlaid to give extra depth of tone. Some sharp lights were pulled out with a putty rubber.

MONOCHROME

Many people believe monochrome to mean black, white and shades of grey. In fact the word monochrome means "one colour", so any colour can be used. However, most monochrome work tends to be fairly neutral, based on browns or bluish, purplish or reddish greys.

The use of monochrome is ideal for people who have difficulties with tone. Using just one colour means that there is only tone to make the subject work. The old masters often made sketches in monochrome to see if

a subject would be satisfactory: if it works in tone it should work when full colour is used. Rubens, Rembrandt and many of the Dutch painters often relied on tonal sketches and many were known to use a tonal underpainting, on top of which coloured glazes and scumbles would be applied.

I would suggest that the term monochrome can also be applied to paintings that have more than one colour, but are so restricted in colour that they appear as a medley of closely related greys or browns.

My portrait study of *Jamaya* is an example of this. I liked the colour of the hardboard and so primed it with an acrylic matt medium. The colours used were the earth colour terre verte to which Indian red was added to make the greyish brown. Alizarin crimson was used to warm the cheeks and white to lift out the lights. Careful use of light against dark helped to model the forms – see how counterchanges of tone in the hands tell as changes of direction in the fingers, and how these then work against the chin. Despite the colours used in this portrait, the overall effect is of a monochrome subject.

LEFT Jamaya;
egg tempera; 152 x 78mm (6 x 3in); by Tony Paul.

Much the same can be said of the oil *Heading for St Marks, Venice.* Painted on a raw-sienna-tinted canvas, cerulean, ultramarine, Indian red, cobalt green deep and flake white were used in this small painting, the red and green making a green-greyish colour, while the purplish-grey of the Salute in the background was based on Indian red and ultramarine. There is a strong sense of light in the painting, the gondola almost a silhouette against the bright water.

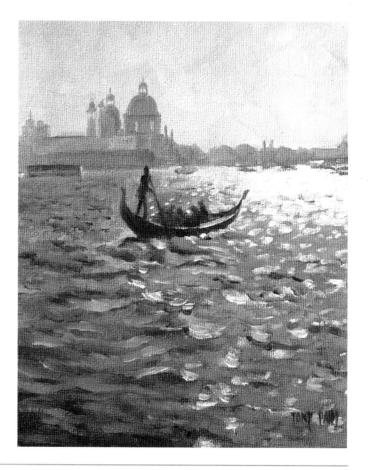

RIGHT Heading for St Marks, Venice;
oil; 254 x 203mm (10 x 8in); by Tony Paul.

ABOVE The White Cloth;
oil; 482 x 330mm (19 x 13in); by Peter Kelly.

Peter Kelly's evocative paintings are similarly restricted in colour, often giving a monochromatic effect. He uses traditional oil-painting techniques based on a solid underpainting over which several transparent glazes of colour are laid. These are offset by carefully applied areas of lighter colours, which are then scumbled over the darker colours. His still life painting *The White Cloth* has sonorous darks and strong lights, the overall effect is a purplish-brown monochrome.

TONAL COUNTERPOINT

Tonal counterpoint is the laying of one tone against another to create a sense of form and to make the elements in a painting read against one another. In the pastel painting *The Millpond Bridge* there are four basic tones – light, half-light, half-dark and dark – with some of them blending to make quarter tones.

When painting the picture, I was careful to make sure that each colour I applied had a tone that helped to create the forms of the trees, path, water and bridge, and to help each element read against the next. When the colour is strong it is sometimes hard to read the tones, but if you half-close your eyes and peer at the subject through your eyelashes you will subdue the colour and the tones will be more apparent.

Starting at the back of the painting you will see that I have separated the trees not only by colour but also by playing light against dark – see how the light edge of the left-hand tree makes it stand out from the brownish one, and how this blends into a lighter tone which, in turn, is set against the dark of the lane beyond. If you look at the painting carefully you will see this kind of counterpoint throughout the work. See how the structure of the bridge is described by changes of tone alone.

I have made a four-tone separation in monochrome that shows these tones without the confusion of the colours (see below right).

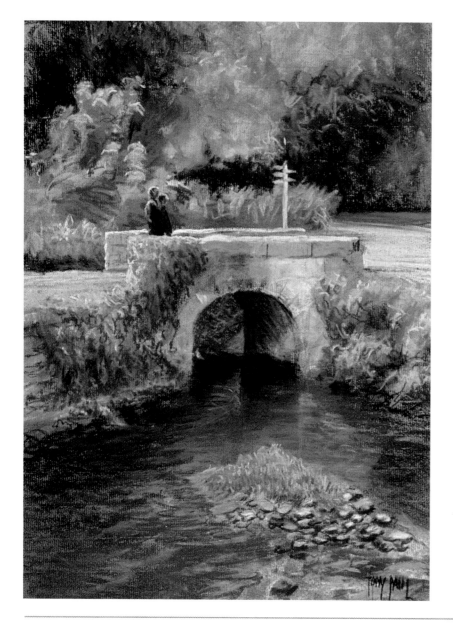

LEFT The Millpond Bridge;
pastel; 558 x 381mm (22 x 15in);
by Tony Paul.

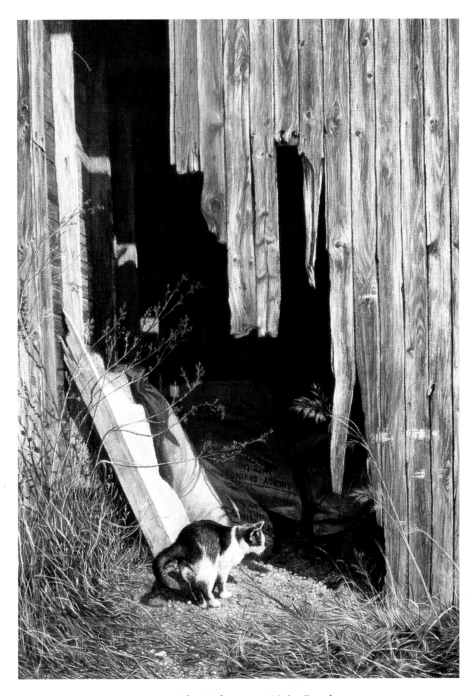

ABOVE The Pink Barn at Noisy Dave's;
egg tempera; 406 x 305mm (16 x 12in); by Tony Paul.

My tempera of *The Pink Barn at Noisy Dave's* is quite strongly tonal. The sunlit, broken door stands out dramatically against the dark interior, and when I decided to include the cat I had to be sure that it would work both against the dark of the barn and against the pale tone of the broken box and the feed sack. Had I placed the cat's dark back against the interior of the barn the tones would have been too similar and, at first glance, the white of the cat would probably have read as a piece of discarded rag or a torn plastic sack. Clearly, placing its back against the lighter box and sack, the head against the dark of the barn interior and the white legs and underbelly against the mid-tone of the ground, has made sure that he reads strongly against his background.

In Peter Kelly's *Museum of Modern Art, Istanbul*, tone has been used skilfully to create an impression of strong light coming through the window. We read the white of the window and its reflection on the polished floor as light and accept that the mid-grey of the gallery walls is in reality a pale, perhaps white, wall. We read it as pale because all the other elements in the picture are so much darker. If we look at the grey's edge against the white of the page it is amazing just how dark it really is. It is all about getting the relationships right.

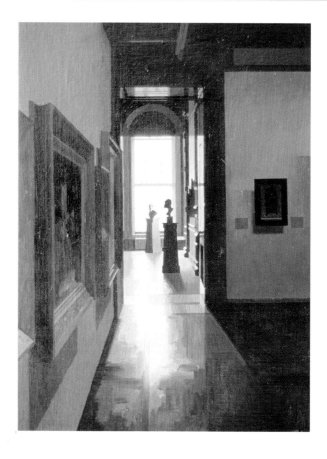

RIGHT Museum of Modern Art, Istanbul;
oil; 356 x 229mm (14 x 9in); by Peter Kelly.

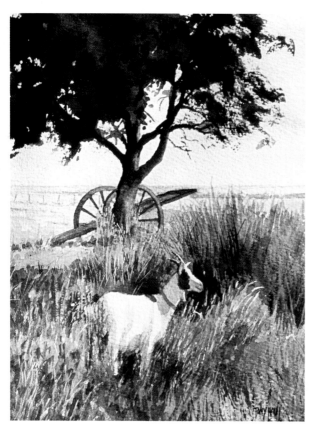

My watercolour *Paquerette* is, again, broadly based on four tones. The tree is strongly dark against the sky, while the sunlit background is kept pale. The long grasses behind Paquerette are slightly darker and break across the background, and as they come down they darken to throw the goat out clearly. Foreground grasses and seed heads also appear sunlit against the dark. The whole tonal structure combines to give the effect of bright sun.

LEFT Paquerette;
watercolour; 228 x 203mm (9 x 8in); by Tony Paul.

PART THREE
TONE AS COLOUR

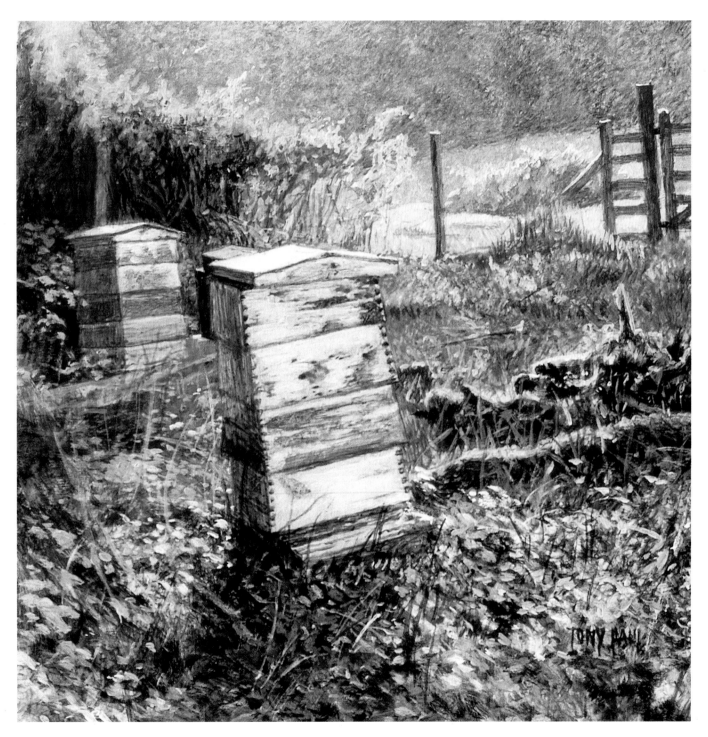

ABOVE Beehives at Kingcombe; *egg tempera; 229 x 203mm (9 x 8in); by Tony Paul.*

COLOUR AND TONE

In my experience most students grasp the principles of tonal control well when dealing with subjects of limited, pale or subdued colours – in other words when the tones tell the story. However, when full-blooded colour dominates, its effect on the brain can be so all-consuming that tone gets overlooked.

I believe that understanding tone through colour is one of the most difficult aspects to grasp when painting. Colour is seductive: the brighter it is, the more complete the seduction. Perhaps it is because the cone receptors in our eyes do not read tone well; or maybe it is because, in bright conditions, the rod receptors – which read tones so well in low light – are effectively asleep; it may also be that we are so concerned with mixing the exact colours as we know them, that we don't mix what we actually see, as modified by light and dark. I suspect the answer lies in a combination of all three causes.

Every colour has a tone and it sits within a tonal range in relation to other colours. When its tone isn't right it can be modified, perhaps adding white to lighten it, or a deeper-toned colour to darken it. On the right is a tonal scale, in the centre of which is a greyscale of ten gradations from white to black. To its immediate left is a tonal scale based on crimson and to the right one based on Prussian blue. The natural tone of both of these colours when applied densely is fairly dark: we can see that the natural tone of crimson is very near the dark end at 8, while the very powerful Prussian blue is almost black at 9.

I have added other colours to demonstrate their natural tones within the same scale. Yellows, by their very nature, tend to be pale, with lemon yellow rating at 1 and cadmium yellow deep at 2. Cadmium red is graded at 5 and cerulean at 7.

Adjusting the tones of these colours can only be done by lightening or darkening them. Lightening can be done either by adding white (for pastels, oils, gouache, tempera and acrylic) or by dilution (for watercolour, acrylic used as watercolour and oils used in thin glazes).

Lightening the colours is a relatively easy exercise, but colours such as yellow, which have a naturally paler tone, will need considerable darkening to adjust them. I have seen students piling on more and more paint in the hope that this will achieve the desired result. With the exception of inherently darkish transparent colours this measure is unlikely to work.

How to darken a colour needs careful thought. The simple solution seems to be to add black. Yes, it will darken a colour, but it can also change the character of some colours or make them look dirty. Cool reds, blues,

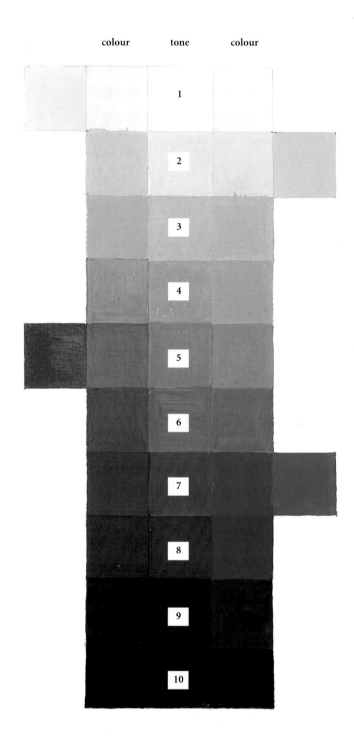

colour	tone	colour
	1	
	2	
	3	
	4	
	5	
	6	
	7	
	8	
	9	
	10	

greens and purples seem to be least badly affected by adding black, while the character of yellows and warmer colours made with yellow can easily be destroyed, with yellow becoming a dirty-looking green, for example. A better solution here is to add raw umber.

Different Colours of the Same Tone

Sometimes, perhaps in an area of a painting that is fairly featureless, it is useful to paint with varied colours of the same tone (see right). Because there is no tonal change the eye reads it as featureless, yet there is something of interest to occupy the eye of the viewer. The colours work well together and give a kind of sparkle to the area in question – far more than applying a single colour. Monet used this effect in many of his paintings.

Here, in the sketch *Spring Trees*, tonally similar greens, violets and blue-greys are shown in use. Some of Gregory's works are painted in a very close-toned, high key, so lacking in tonal change that he is reluctant to have them reproduced in black and white because they almost disappear. The purity of the colours that he has used and their generally pale tone gives a good feeling of light. It takes a great deal of experience to make paintings like Gregory's work. A thorough understanding of the subtleties of tonal control is fundamental.

LEFT Spring Trees;
oil; 445 x 368mm (17½ x 14½in);
by Gregory Davies.

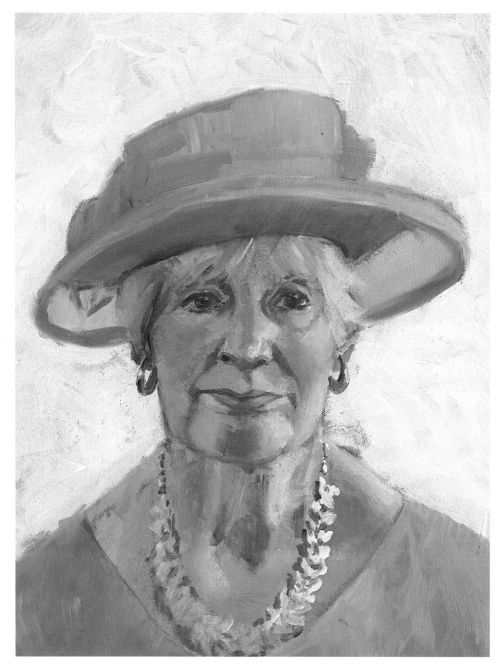

ABOVE Enid in Hat;
oil; 305 x 240mm (12 x 9in); by Tony Paul.

A Portrait of Enid

In this sketch portrait of *Enid in Hat* the lights and darks are important in giving a look of form to the head. Often students will look at a head as a simple pinkish shape on which the features can be planted. Although the result may have the superficial look of the sitter, it will also appear flat and unreal.

There is much more to getting a likeness than just the accuracy of the drawing and the placing of eyes, nose and mouth. Much of it relies on the structure of the head. If the painting has promise, there will be a likeness even before the features are established. The way in which the forms of the face fit into one another is fundamental. The structure is described using both tone and colour, but it is easy to become so absorbed in mixing the right colour that the tone of that colour can be forgotten.

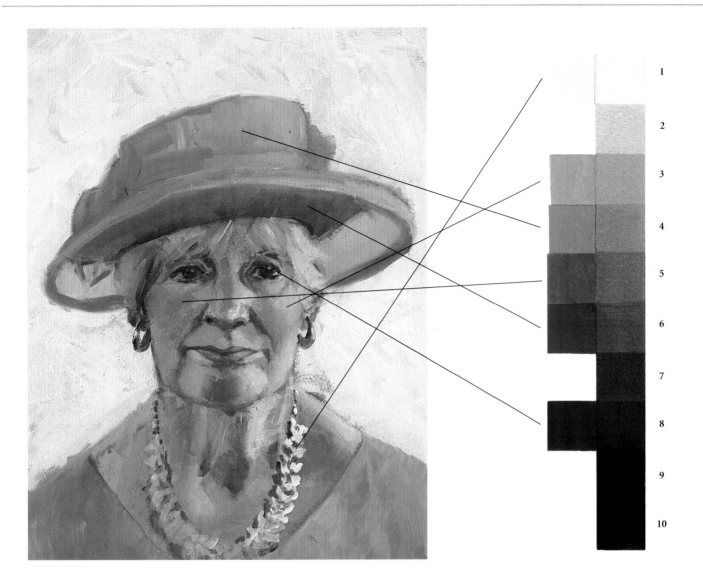

We *know* that Enid's right- and left-hand cheeks are the same colour, but they do not *appear* the same. In order to paint realistically we have to paint tone and colour as we see them. You can see that the lit side of Enid's face is 3 on the tonal scale, while the shadow side is 5. The lightest areas are the necklace and the tiny speck of light in the corner of the right-hand eye.

Note the change in tone between the dark and light areas of the hat (4 and 6 respectively) and the way that the tones change across the structure of the face. We are aware that the eye lies within a socket and that the ridge of the nose rises from one cheek and returns down to

the other one. See also how the cheek turns from the light at the side of the face into the darker crease at the edge of the upper lip. Enid's blonde hair changes from right to left: in the light, it is warm and bright, while in shadow the colour is cooler and darker. Had I painted the hair on the left in the same tone as that on the right it would have been incongruous. Note, on the right, how the hair is light against the light green of the hat, while on the left the hair is darker than the green. Despite this, the tonal relationship between the hair and the adjacent flesh tone remains similar – the hair being a little lighter than the flesh.

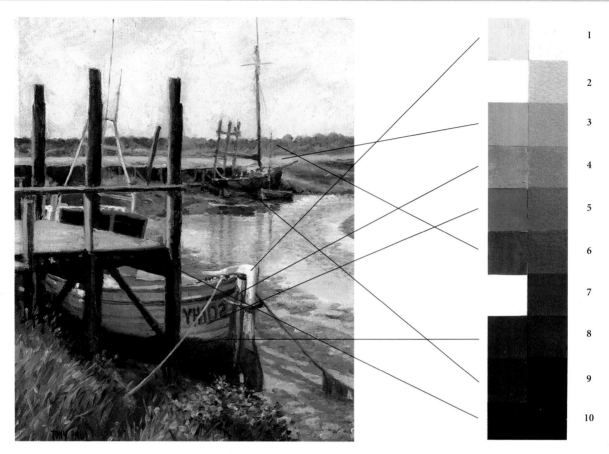

ABOVE Low Tide, Thornham Creek;
oil; 279 x 229mm (11 x 9in); by Tony Paul.

Low Tide, Thornham Creek

There is a full range of tone in this little oil painting, with tonal counterpoint used throughout to make one aspect read against the next and to give the effect of bright sun.

The background, beneath the pale colour of the sky, is divided into three bands of different tones. The mid-tone (6 on the tonal scale) gives way to the lighter tone of the pathway (3 on the scale). This then gives way to the dark and mid-tones of the creek bank.

The strong contrasts and geometric shapes of the foreground landing stage pull it forward, while the foreground boat has been worked in a variety of tones – from the almost white (1 on the scale) of the tiller bar to the dark of the cabin interior and dull red of the lower hull.

The upper side of the hull, although it represents white, is painted in a mid-tone (5 on the scale). It reads as white because all of the other colours in the shaded area are proportionately darker – even the shaded orange colour of the rust streaks on the stern are darker, rising a tone or so as they move into the light (4 on the scale).

I did not use black, so all the darks were made using burnt umber and ultramarine. This has given a softer, almost purple edge to the darks. (In my view, absolute black and pure white should be reserved for the ultimate darks and lights, and applied in small touches. Too much of either in a painting can lessen its dramatic effect significantly.)

To see how tone is dependent on what it lies beside, take a look at the white-painted gantry above the cabin of the boat in the foreground. Against the darker land the gantry appears light, but where it sits against the light of the sky, in accordance with tonal counterpoint, the sky appears lighter than even a white-painted structure. Despite its sudden change of tone it doesn't look odd. The shadow on the mud to the right of the boat is more a change of colour than a change of tone. I wanted to get a feeling of light in shadow, so the colour wasn't made too dark, but I wanted to contrast the temperature counterpoint (see page 39) of the sunny and shaded areas. The darkest dark is in the shaded framing of the foreground landing stage.

LOCAL COLOUR

Local colour is the colour of a surface seen in good light without the effects of shadow on it or strong light behind it. It is the actual colour of a surface.

Often, when students paint a subject, they paint using local rather than observed colour. An example of this is a portrait where the whites of the eyes are painted or left brilliant white, giving the impression that the head is illuminated internally. Accurate observation of the sitter would reveal that, in fact, the eyes are largely in shadow, with the whites reading as grey.

It is easy to fall back on what we know – we don't have to look at the subject – we can effectively make a painting from the brain's box of knowledge. But however good the brain is, it will never be as effective as working from close observation. It is hard work but it pays dividends.

Take a lemon for example: the local colour is, of course, yellow (Figure 1); but put it in a situation where it is subject to an effect of light and shade, and much of its colour will not appear yellow at all (Figure 2). One of the pitfalls for a beginner is that he or she paints a picture in bits, using local colours, without relating one area to another in terms of tonal structure.

Consider this evening snow scene (see right), painted using local colours: the snow is white with only a hint of shading; the man is in coloured clothing and the building is painted as if viewed under direct light. Even the bush on the left is a bright green. I have also put a light in the downstairs window but it doesn't read as one – it simply looks like a drawn curtain. Although it has been painted reasonably well, there is a lack of reality to this scene. Something isn't quite right. If this is a sunset, the sky should be the lightest part of the painting – it is the source of the light. Everything else, including the snow, should appear darker. The sky, instead of reading as light, looks heavy and dull.

Figure 1

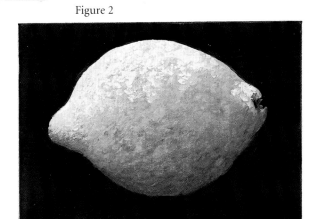

Figure 2

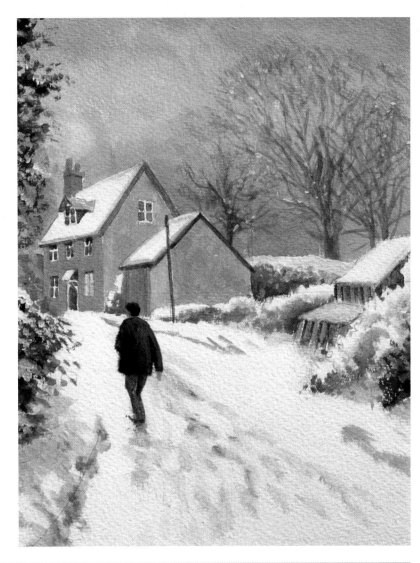

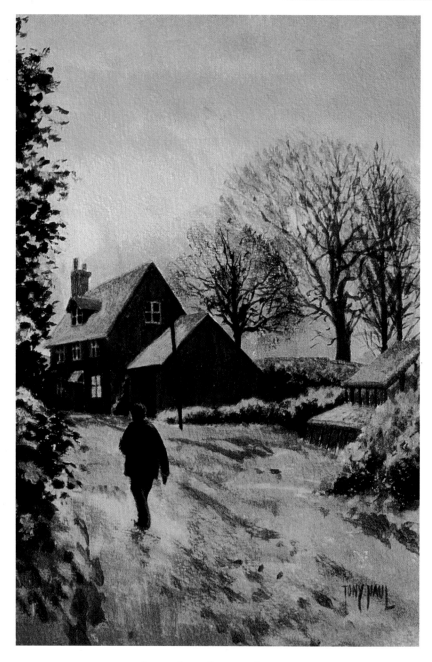

ABOVE Snow Scene at Sunset.

Here I have painted over the original using observed colour as modified by the light conditions. The sky has not been lightened, but now reads as the source of light. The snow is darker than the sky but, as its local colour is white, it is the next lightest subject. It has picked up the colours in the sky much as water would but, because some of the light has been absorbed by the snow, it is darker. See how dark the snow on the roof appears against the sky – yet it still reads as white. Everything else in the painting has been darkened so that the tonal relationships are maintained. Even the light in the downstairs window has been darkened, but it still reads as light. See how dark the snow appears against the white of the page. The colours of the man, trees and house have been suitably darkened to make sure that the tonal counterpoint in the painting works. I have put some light in the greenhouse windows to show that they are glass.

COLOUR TEMPERATURE

Figure 1

WARM

| burnt umber | cadmium yellow | raw sienna | cadmium orange | cadmium red pale | burnt sienna | cobalt blue | oxide of chromium |

COOL

| raw umber | aureolin | yellow ochre | permanent rose | alizarin crimson hue | Indian red | manganese blue hue | phthalo green |

Establishing a feeling of distance in a painting can be difficult. Sometimes objects placed in the background seem reluctant to play the role they are given, instead imposing themselves upon us by drawing our eye to them or appearing to hover in the air in the foreground. Sometimes the problem is that the temperature or tone of the object is wrong for its place in the picture. Generally speaking, warm colours tend to come forward in the picture plane, while cooler colours recede.

In landscape subjects there is an effect called "aerial perspective". This is a gradual cooling of colour and lightening of tone as foreground gives way to background. It is caused by moisture, dust and other particles affecting the light as it passes through. The blue element of light is scattered more readily than any other wavelength – this is why a clear sky is blue – and this scattering has a blueing and softening effect that increases with distance.

Above are strips showing spectrum colours of both a warm and cool temperature (Figure 1). As you can see from the colour wheels in Figure 2, mixing the warm colours results in a vibrant orange, while green and purple are soft and muted – ideal in a warm-coloured subject. The colour wheel in Figure 3 is made with cool colours, however it has vibrant greens and purples but a duller orange. The temperatures of the colours of the two wheels are quite different.

By using brighter and warmer colours in the foreground with cooler and more subdued colours in the background, you are likely to achieve a good feeling of distance in landscape subjects.

Figure 2

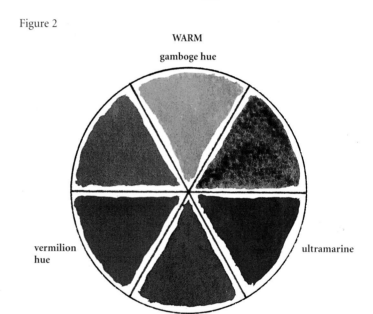

WARM
gamboge hue

vermilion hue

ultramarine

Figure 3

COOL
lemon yellow

alizarin crimson hue

phthalo blue red shade

COLOUR AS AFFECTED BY AMBIENT LIGHT

We have talked about the way that colours can have warm or cool characters, but often the temperature of the light falling on the subject will also have an effect on the colours we use to represent it.

If we take my painting *The Thames at Westminster*, it is immediately apparent that the subject is of a cold winter's day. The blues, greens and purples are all cool and the watery sun that strikes through the bare branches of the trees and dapples the Embankment, gives little warmth. Aerial perspective is in evidence here: see how the Houses of Parliament in the background become cooler and more diffused as they recede into the distance.

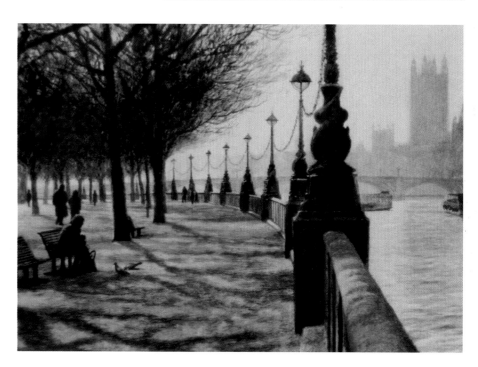

ABOVE The Thames at Westminster;
egg tempera; 501 x 762mm (20 x 30in); by Tony Paul.

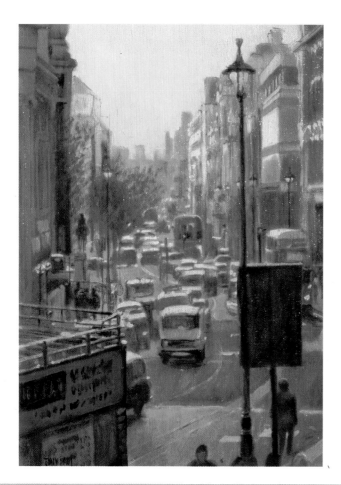

Still in London, we have a very different subject in *Warm Evening, Pall Mall*. It is early evening in the summer. It is hot and sticky, the fumes from the rush hour traffic make your eyes sting and the light is yellowish, giving a warm cast to all the colours. Again, see how aerial perspective has been used, with the definition of the buildings softening as they recede into the background. See, also, how the form of the bus behind the sign on the right has been described simply, but effectively, through the use of tonal counterpoint.

Left Warm Evening, Pall Mall;
oil; 356 x 254mm (14 x 10in); by Tony Paul.

TEMPERATURE COUNTERPOINT

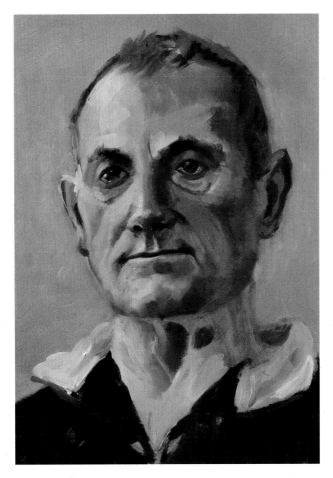

ABOVE Frank;
oil; 305 x 241mm (12 x 9in); by Tony Paul.

Do not be deceived into thinking that a painting should contain colours of only a warm or cool temperature, however. Certainly, as I have demonstrated, paintings using just one can be used to effect but many, if not most, pictures will contain elements of both.

Their juxtaposition in a painting can actually improve it. A painting that is overloaded with warm colours will probably benefit from the addition of smaller areas of a cooler nature. This is likely to have two simultaneous effects: firstly the painting will have islands of cool that will prevent it overheating; and secondly, by their very coolness, these areas will emphasize the heat in the painting. The cool purplish colouration of *The Thames at Westminster* (see above left) was quietly countered by the pink and ochre dappling on the pathway and in the trees and sky. The watery February sun does little to take the chill off the scene but, without it, the painting would appear virtually as a monochrome.

There is, perhaps, more colour in *Warm Evening,*

Pall Mall (see below right), but the temperature is hot, creating the impression of a sultry summer's evening. There is just enough bluish-grey to prevent the painting overheating and, again, to reduce the monochrome effect. See, in the white van that follows the open-topped bus, how warm (and slightly lighter in tone) its roof is in comparison to the cool grey of its bonnet. This emphasizes the changes of plane and really gives the vehicle a three-dimensional appearance.

In portraiture or figure work temperature counterpoint is extremely useful. Where light is falling from the left of the subject, for example, the colours used will, in all probability, be warm, but in moving from the front to the right-hand side of the head, the tone will change, becoming cooler as it does so. An example of this can be seen here in my sketch portrait of *Frank*. See how cool reds and purple-greys work against the warmer colours of the lit planes of Frank's face. You will also see that their tones are darker.

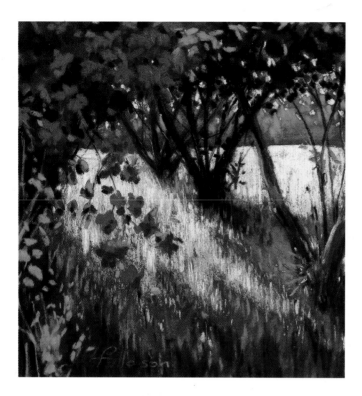

In sunny landscape subjects, areas of cool, often dark, colour are useful in shaded areas, the darker tones implying a lack of light in that area and the cooler colours implying a sanctuary from relentless heat.

Cool shadows, reflected light and warm sun all characterize Linda Patterson's *Shadows*. I particularly like the way that the cool, purplish fronds hang, almost in silhouette, against the yellow of the grass, and how the light, reflected dully from the ground into the underside of the tree, has been turned to cool green. It appears warm against the cool greens and purples of the foliage.

LEFT Shadows;
pastel; 178 x 178mm (7 x 7in); by Linda Patterson.

Gregory Davies's oil *St Pietro, Tuscany* has a good feeling of heat, with the warm orangey yellow opposed by a cool violet. See how the foreground haystack changes in temperature as it turns away from the light, without much change in tone.

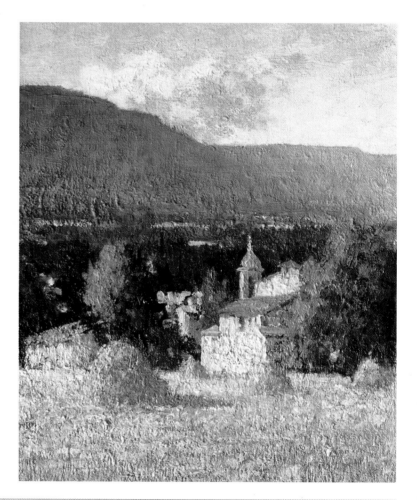

RIGHT St Pietro, Tuscany;
oil; 355 x 229mm (14 x 9in); by Gregory Davies.

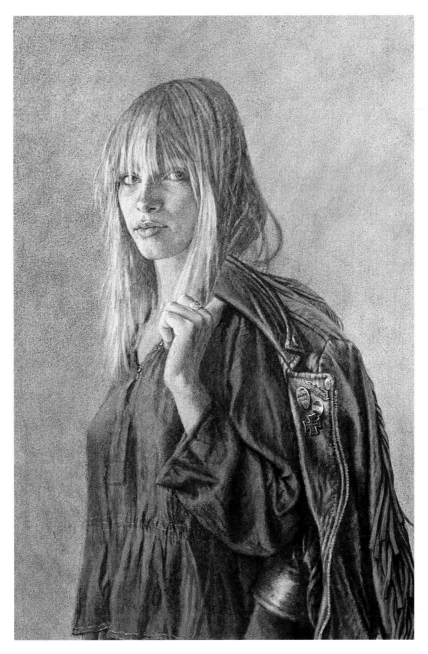

ABOVE The Motorcycle Girl;
acrylic; 711 x 601mm (28 x 24in); by Tony Paul.

In my acrylic of *The Motorcycle Girl* I have used the technique throughout the painting. The background colour has been sponged on in several layers of pure, but dilute, colour. This sponging was carried over the areas of the figure and the figure worked over the background. Here and there the background has been allowed to show through. As you can see from the close up detail, much of the painting is composed of small dashes of paint, the colours of which combine to give an overall effect.

PAINTING IN HARMONIC COLOURS

Figure 1

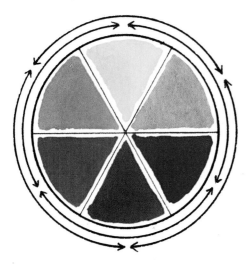

Figure 2

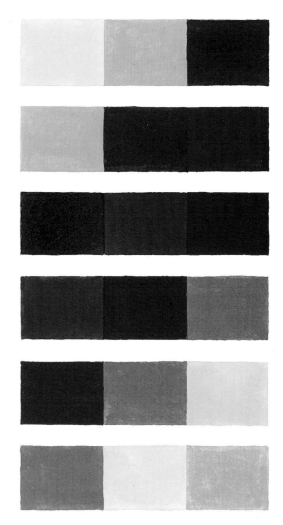

Some people, when working from a subject, believe that they have to replicate exactly what they see without alteration. Others may move things around, delete or add certain things. Many wouldn't consider changing the colours, however, probably because they wouldn't know what to put in their place.

But there is no reason why the colours in a subject shouldn't be altered to create a certain colour scheme. The great worry is that the colour scheme won't work, and yet there are certain arrangements that are virtually guaranteed to be successful. The first of these is a colour range based on harmonic colours.

Harmonic colours are easiest understood if related to the colour wheel (Figure 1). If a painting is carried out using, as a basis, three adjacent colours on the colour wheel – for example green, blue and purple – the result should give a feeling of unity as there is blue in both green and purple. Other harmonic colours would be blue, purple and red (purple contains both blue and red); purple, red and orange (both orange and purple contain red); red, orange and yellow (orange contains both red and yellow); orange, yellow and green (orange and green both contain yellow); and yellow, green and blue (green contains both yellow and blue) (see Figure 2).

The three colours will dominate the painting, usually with one taking the lead and the other two in support. The scheme is not totally rigid, and nuances of other colours can be added to give a naturalistic effect, providing they don't compete with the three main players.

Harmonizing Colours

There are other colour schemes, such as those illustrated in Figure 3, that, although not strictly related, have a

Figure 3

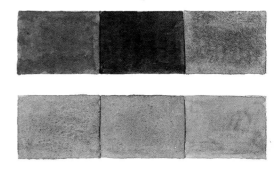

harmonic feel to them – usually based on a central restrained colour such as brown or grey with colours added. Again, the fact that any mixes will contain the central colour means that they will have a harmonic quality.

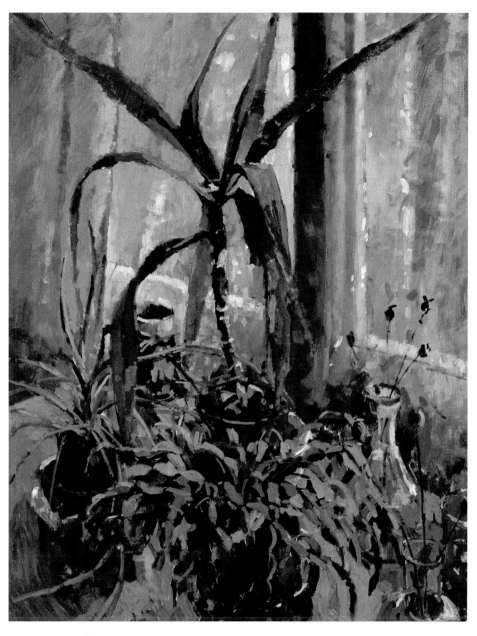

ABOVE Still Life;
oil; 559 x 407mm (22 x 16in); by Robert Palmer.

The oil painting *Still Life* by Bob Palmer is in a quiet harmonic palette consisting of a dull ochre, blue-grey and green (yellow/blue/green). The lightest areas are the small ticks of light on the glass bottle and the pots. Bob has made sure that the source of light reads as such. Despite the obscuration created by the heavy lace curtain, it is clear that it is the daylight outside the window that lights up the still life. (Try peering through your eyelashes at the painting – this helps in reading light.)

See how tonal counterpoint has been used in the window frame. Its outer edges are whitish, while the sides are greyer in colour, indicating that there is a change of direction, and so less light falling on it. It still reads as white, but white modified by tonal considerations. The inner-facing plane of the frame is dark grey, yet it reads as a solid white structure against light. The pots are very dark, emphasizing the green of the plants. This painting is a superb example of how to use tone and colour effectively.

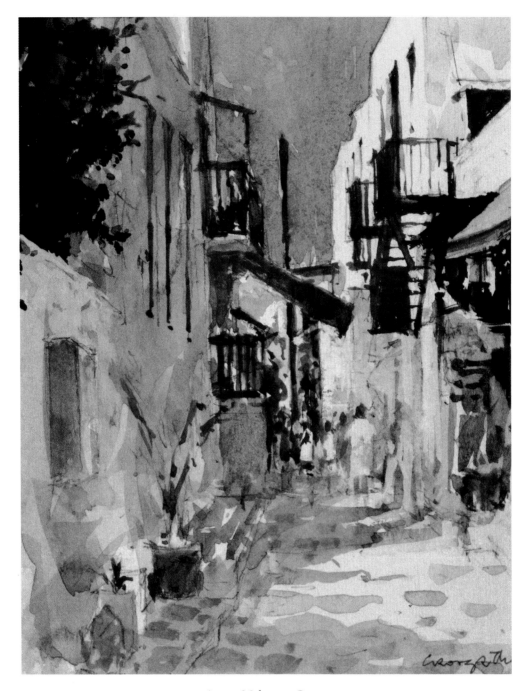

ABOVE Mykanos, Greece;
watercolour; 305 x 229mm (12 x 9in); by George Thompson.

In George Thompson's watercolour *Mykanos, Greece*, the harmonic colours are purple, red and orange. I would imagine that only two colours (apart from the small touches of blue-green) were used in this sketch: an orangey-red-brown – perhaps burnt sienna – and ultramarine blue. A touch of the brown in the blue has created the slightly purplish sky colour, while a dense and fairly equal mix has been used for the dark, hard shadows of the balconies, blinds and stairs. The red is the dense brown, while the orange is a fairly dilute version of the brown. The hard darks emphasize the strength of the light, and sensitive observation will show how light, reflected from the sunlit walls, has softened the shadow on the shaded side of the narrow alley.

PAINTING IN COMPLEMENTARY COLOURS

Figure 1

Figure 2

Figure 3

Another colour scheme that has found favour with many artists is one based on a pair of complementary colours – those opposite one another in the colour wheel – red and green; blue and orange; and yellow and violet (see Figure 1).

Not only are they diametrically opposite in the colour wheel but they are also opposite in terms of temperature – the red, yellow and orange being warm, while green, blue and violet are considered cool. Again, elements of other colours can be used if they take supporting, rather than leading roles in a painting.

Of course, mixing the complementary colours will result in tertiary colours being produced (each primary colour being opposed by a secondary). They make a good foil for the brighter complementary colours and, because they contain a complementary colour, they will not conflict with each other.

Although the left-hand colours in Figure 1 are bright, there is no reason why the spirit of the colour scheme cannot be employed using more muted colours, which could broadly be described as complementary. For example: a soft salmon-pink instead of red, against a greyish-green, a soft greenish-blue against a burnt sienna instead of orange, and a tan instead of yellow with the purple a dull magenta (Figure 2).

Care must be taken, even with complementary colours, to ensure that one colour is more dominant than the other, in quantity, saturation or tone. When complementary colours of equivalent brightness and tone are juxtaposed they will make each other appear brighter and be quite uncomfortable on the eye (Figure 3). The use of a little of the complementary colour in a painting is well established. Constable often used touches of bright red in his very green landscapes.

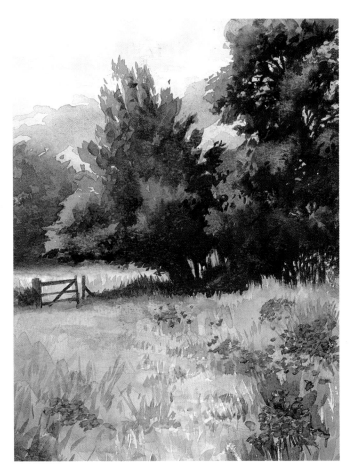

In my painting *A Field at Castle Rising* the main colour is green, and varies between a bright yellowish-green, where it is catching the light, to one that is almost black. A bright orangey-red has been used for the poppies with only slight tonal variations.

Hints of other colours are included in the painting and these are, again, complementary. The warm yellow of the dry grass in the distant field could be considered a complementary colour to both the blue of the sky and the dull purplish cloud.

LEFT A Field at Castle Rising;
watercolour; 229 x 305mm (9 x 12in); by Tony Paul.

Eric Bottomley's *Streaks of Evening* is, in the main, a composition in purple and yellow. The orangey-yellow of the setting sun, reflected off the sides of the train and its carriages, is perfectly opposed by the bluish-purples of the sky and land. Again, other colours are present – magentas and tertiary greys – foils that have sympathy with the painting's main scheme.

ABOVE Streaks of Evening; *oil; 509 x 915mm (20 x 36in); by Eric Bottomley.*

PART FOUR
HOW TO USE AND
CONTROL LIGHT

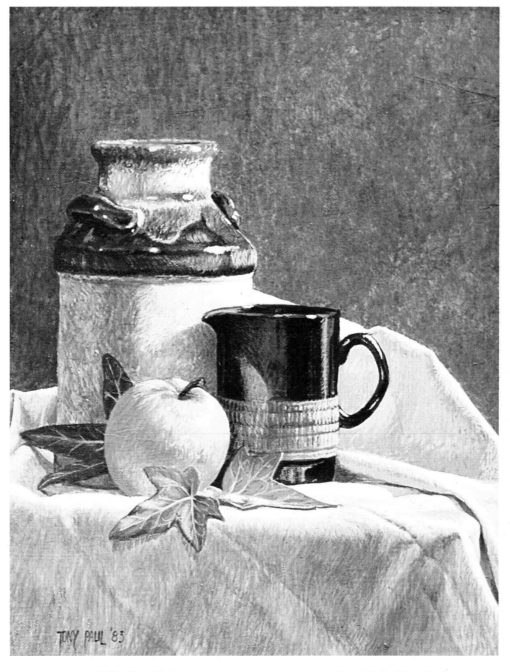

ABOVE Still Life with Ivy; *egg tempera; 224 x 178mm (9 x 7in); by Tony Paul.*

LIGHTING A STILL LIFE

Many still lifes are spoiled before they are begun, simply because the artist hasn't given him- or herself a chance to make the painting work effectively. One of the most common reasons for failure is because the light falling on the subject hasn't been considered properly.

As we have seen, light is our ally, it can create and reinforce form and give mood to a painting. There is no excuse whatsoever to put up with poor light when it comes to painting a still life. This is one of the few subjects that is totally under the control of the artist: you can set up a still life wherever you like; you can move the objects around to create an interesting composition; and you can light it how you want. Furthermore, unless it is perishable, you can leave it where it is, taking as long as you like to paint it.

If you don't want to use daylight, which can be fickle, you can use artificial light in the form of a spotlight or an anglepoise lamp. You can control warmth or coolness by using ordinary light bulbs, fluorescent tubes or daylight bulbs. Placing the light source at varying distances from the subject will produce different qualities of light from the stark to the softly modelled. Harsh lighting, perhaps created by using a spotlight and turning out the room lights, can be dramatic in its effect, although, of course, you will need a shielded daylight bulb set-up to paint by.

Alternatively, normal room lighting can be used, enhanced a little by a carefully positioned lamp. Diffused light can be created by bouncing a strong light off a light-coloured wall or other surface. Another way of controlling light is to provide obstructions to it by pulling down blinds, screening off the light to create shadowed areas, or by putting the set-up in a box. It is all completely under your control.

Figure 1 shows a simple still life that has been set up with the source of light directly on its front. Note how flat the objects appear: there are few shadows and the jug is only given form by the ridges that the potter made when it was thrown, otherwise colour and tone are similar from left to right. The small pot almost appears to be floating, and only the soft reflections on its eggshell finish give a sense of form. The cloth on which the set-up is placed is practically featureless, and the small gourd looks like an amorphous lump. It would be very difficult to make much of a painting from this set-up. The end product is bound to be less than successful.

By putting lamps only on the left-hand side, however, a real sense of form has been created in all the objects (Figure 2). See how important the shadows are in anchoring the items to the cloth. This too has more form, the ridges being emphasized by the light. It would be much easier to make an effective painting from this subject because the forms are more pronounced.

Figure 1

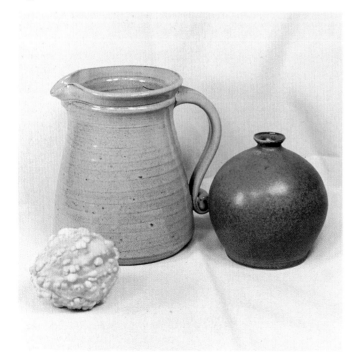

Figure 2

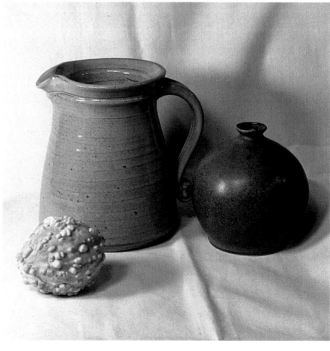

Figure 3 shows a small still life set-up using natural north light coming from the left. If you can, it is always better to use north light, simply because it is softer and doesn't change as much as the direct light of the sun, which can make aggressive shadows that move as the sun goes across the sky. There is also the problem, on a changeable day, of the sun going in and out of cloud, which can be very frustrating.

If you paint in the evenings or would rather have a tighter control of light, then using artificial light is the answer. Table lamps will be effective for broader lighting effects but anglepoise lamps are ideal if you need a more directional light. The ability to alter the height and angle of light is an added bonus.

Setting up the subject in a cut-away box gives a background and restricts light (Figure 4). If you want a more dramatic effect you can restrict stray light falling on the subject by placing it into a deep box with only the front removed (Figure 5). A slot or hole can then be cut in the top corner and the light from an anglepoise can be shone through it. The colour of the background can be improved by hanging coloured paper in it.

Figure 3

Figure 4

Figure 5

Dried Flowers and Lace was set up in the window of my north-facing front room. The subject is against the light, which shines through the white honesty and the buff leaves. The denser flower and seed-heads appear more as silhouettes against the light coming in from the window. Some of the light falling on the window sill is reflected back onto the vertical elements of the window.

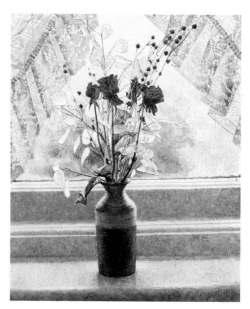

RIGHT Dried Flowers and Lace; *egg tempera; 355 x 254mm (14 x 10in); by Tony Paul.*

Kitchen Shelf by Peter Kelly is a set-up using artificial light. The main source is from the left, but there is some light coming from the front right, which is reflected brightly in the kettle. The dark background gives the impression that the still life was painted in a darkened room with the light playing just on the table top, but that is not the case. The letter and the playing cards at the top of the painting would be much darker if this were so. The wall is just painted in a very dark tone.

LEFT Kitchen Shelf; *oil; 508 x 381mm (20 x 15in); by Peter Kelly.*

The acrylic *Barn Still Life* is based on complementary colours and was set up in a barn into which the light was shining at a steeply raked angle. See how the milk churn is strongly lit on one side and almost black on the other. Because of the large size of the barn there was very little reflected light. Note how the churn is light against the mid-tone of the barn door while, on the other side, it is dark against the timber wall. There is an area of "lost and found" where the base of the churn melds into the shadow across the straw. See how bright the light appears that runs between the churn's shadow and the tines of the forks against the wall. It is the close proximity of the darks that makes the light appear so bright.

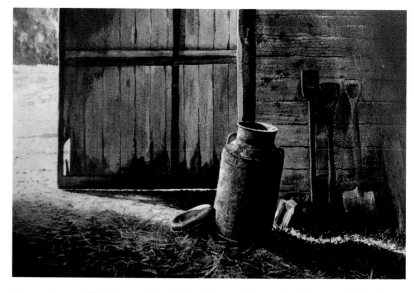

ABOVE Barn Still Life; *acrylic; 305 x 407mm (12 x 16in); by Tony Paul.*

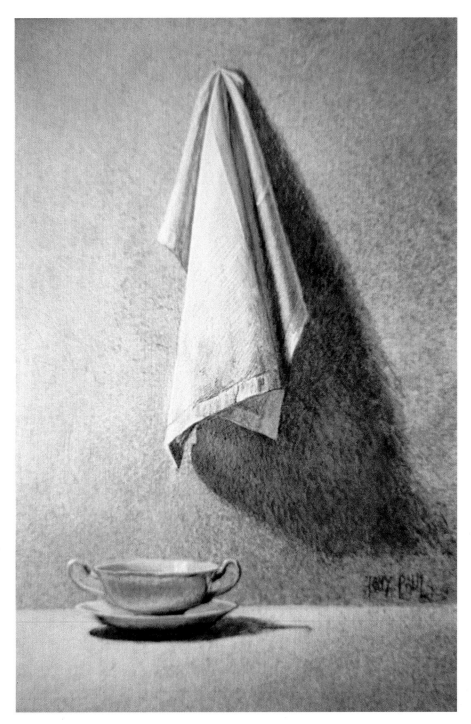

ABOVE White on White;
egg tempera; 203 x 152mm (8 x 6in); by Tony Paul.

All the surfaces in *White on White* are based on white objects bathed in a warm light. The light, coming from an anglepoise lamp to the left of the painting, gives a sharply defined light that softens a little as it crosses the painting. See how much darker the background and table top are on the right of the painting. I was interested in exploring the differences in the action of light on the soup bowl and the hung cloth, and their shadows. I was surprised at how much colour I put into the painting while still giving a feeling of whitish surfaces.

LIGHTING A PORTRAIT

What I have written about lighting still lifes (see pages 50–51) is just as relevant when considering a portrait. Many portraits are ruined before they are begun, simply because the effects of light falling on the subject have not been considered properly. There are no absolutes in portrait painting, it is rather a case of the kind of lighting that would suit the sitter or, alternatively, create the mood you are after.

Tact is probably your best ally in a portrait. Generally speaking soft, diffused lighting works best for women (photographers often use soft-focus lenses), as it will provide gentle modelling without emphasizing lines. If the subject is lined beyond her years, or has bad skin, it may be necessary to go for flat lighting as this can "iron out" the skin effectively.

It is no accident that the photographs of glamorous models on the covers of women's magazines are usually taken with very flat lighting and next to no tonal modelling being used. This emphasizes the eyes, nose and mouth, which are usually in very sharp focus.

While this is fine for a magazine, the same kind of lighting would not work too well for a painted portrait as the features would appear to be sitting in a puddle of formless pink. In Figure 1 a sitter was photographed using flat lighting. Other than the features, there is little information with which to model the facial structure. Photographs taken using flash will have a similar effect and so should also be avoided.

Figure 1

Natural daylight is generally ideal, providing that the room into which it comes is light and airy. The light will have a direction and will render flesh colours naturally, without the yellowish cast of light bulbs or the greenish cast of fluorescent tubes.

The watercolour *Tony Gray* was painted using natural daylight. Tony has a strong face, proud but with a slight hint of sadness. I thought that I would have him looking out towards the light. It seemed to suit him. See how solid the head appears because of the action of the light. His forehead is pale and yellowish, receiving the full brunt of the light. In contrast, his rosy cheeks, turned away from the light, are cool and deeper toned.

As the planes across the face change tone, they describe the facial forms. There is a strong light on the profile of the nose, but as it returns to the cheek it becomes a slightly darker tone because it is receiving only raked light. The cheek, being in much the same plane as the ridge of the nose, becomes lighter again, then darkens as it turns into the side of the head. The back of the neck is darker still, receiving only reflected light from within the room. I placed a dark background around the portrait to give more drama to the head.

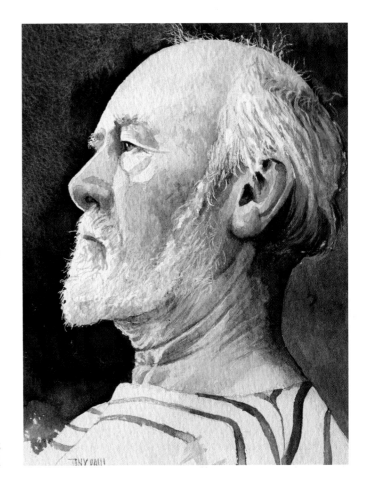

RIGHT Tony Gray;
watercolour; 406 x 305mm (16 x 12in); by Tony Paul.

Harsh lighting can create a strong mood. It can evoke strength and reveal, or imply, personality: it can even be sinister. I decided to paint a self-portrait using acrylic. I set up a lamp fairly close to the side of my head, with a second one some way off on the opposite side. This seemed to give the strong lighting that I was after. I was determined to adopt a facial expression that would reflect my genial, happy-go-lucky personality, but as I painted, concentration took over and I ended up with the rather severe expression you see, hence the title *Self-portrait as a Grumpy Grouch.* See how the lines of my forehead have been exaggerated and how the bags under my eyes are emphasized by the light. It still looks like me – but older and grumpier.

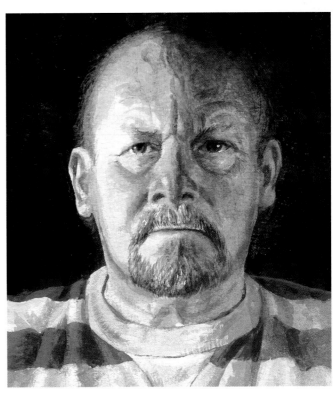

RIGHT Self-portrait as a Grumpy Grouch;
acrylic; 229 x 203mm (9 x 8in); by Tony Paul.

Harsh lighting can be a rather blunt tool that tends to suit men better than women. To apply it to a woman is likely to age her considerably. It will emphasize any wrinkles and bad skin and she will appear haggard or, even worse, look masculine or rugged.

As mentioned earlier, a diffused light is best for women (see page 54). This is often achieved by reflecting light off a wall, or found where natural light bounces about within a room, especially where there is more than one source of light. There will be no hard-edged shadows, just gentle modelling that will reveal the forms of the head and put subtle light into the shadow areas.

Reflectors, in the form of white art boards or paper, can be used to reflect light on to the face if the side lighting is too strong; or artificial light used in combination with the natural light (but if you want to give the artificial light the same character as the daylight, don't forget to use a blue "daylight" bulb). It is best not to play the light directly on to the face, in case hard-edged shadows are created.

This oil of *Kulab* shows the subject is in the diffused light of a large, well-lit studio. As you can see, there are no harsh shadows, yet the head is gently modelled, with changes of plane in the face being quite clearly stated. The strongest light is from high above on the left. This has given emphasis to the woman's broad cheekbones. She is wearing a vivid pink silk dress and its colour can be seen reflected on the underside of her chin and neck. The opulence of the gold Thai jewellery adds richness to the image and the green background, being complementary to the pink of the dress and harmonic to the gold of her jewellery, enriches the colour scheme.

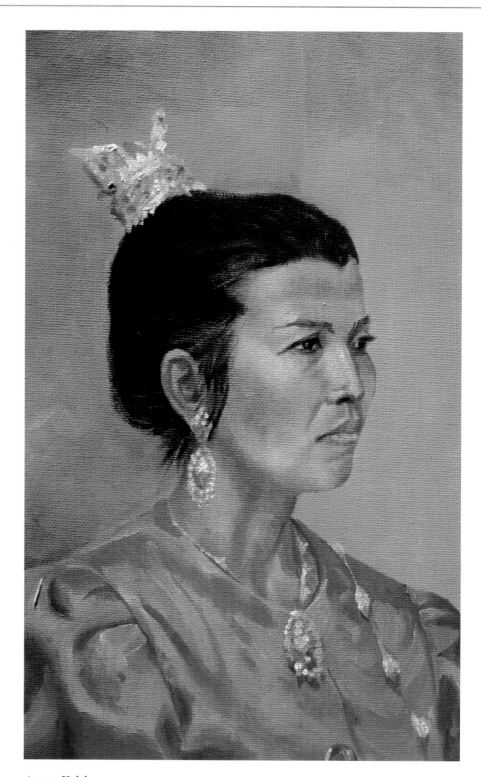

ABOVE Kulab;
oil; 406 x 305mm (16 x 12in); by Tony Paul.

ABOVE Tom;
pastel; 406 x 305mm (16 x 12in); by Tony Paul.

Tom was a pastel sketch painted as a demonstration for my portrait class. He was sitting fairly close to a window on his left, which gave a strong light, while on his right and across the room, another window cast its light more quietly on to the other side of his face. The room was decorated in a warm yellow and, being reflected partly from the walls, the light has picked up a warm, yellowish edge. Again, see how light has modelled his face, there being sharper changes of tone where it was stronger.

Black Creek Pioneer Village Portraits

While holidaying near Toronto in Canada, my family and I paid a visit to Black Creek Pioneer Village. This is a centre based on a nineteenth-century farm that has been created using buildings brought from other parts of Canada and reassembled to build the type of village that existed in the 1860s. It is populated with people who wear the dress of times gone by, and who carry out the activities and trades of past times – a living history lesson of how life used to be, albeit in a reasonably limited and tourist-friendly way.

The village was busy with visitors, and I was not able to sit and sketch the characters in action, so took photographs of three of the costumed "villagers" busy at their activities. The fall of light was all-important and I only managed to find three villagers where the light was good enough to take a suitable photograph without using flash, which would have flattened the image considerably, destroying the character of both model and setting. When I returned home I decided to use acrylics to make small 254 x 203mm (10 x 8in) portrait studies of the characters.

The saddler was busy removing a broken rivet from a rope harness. He was facing a window and the light was on him frontally. The small workshop was well lit, with light being reflected around, so there were no deep shadows, but enough variation in light to model his form well. His bench was placed against the window. As you can see from the portrait, the light made the modelling of his features quite easy, shadows appearing in the hollows of his cheeks and under his chin. These were not dead shadows, but shadows that had a degree of light themselves. For instance, see how there is a feeling of reflected light in the darker areas of the back of his cap and in his apron. As the background was a middle tone, mainly of burnt sienna, the lighter and darker tones of the figure worked against it well.

The seamstress was sitting side on to a window, so I had to make sure that there was a strong feeling of light through it. I enjoyed recreating the light shining through the yellow gingham curtains and upon the side of her dress and head. The light on her features was sufficient to model her face well. See how much darker the wooden wainscoting is to the left of her chair, where the reflected light from the floor was less, and how the wall above it gets slightly darker the further it is from the window. I thoroughly enjoyed painting her dress and sewing machine and the final touches were to add the sampler and the little drawers holding cotton to the back wall. I was careful not to make these too important, however.

For the cook, the lighting was similar to the saddler, being frontal. A smaller window further away behind her gave a softer light on her back, the main shadows being on her side. Looking at the beige wall behind her, you can see how the direction of strong light from the unseen left-hand window softens as it gets further from the main light source. The largely brownish background, and particularly the dark fireplace opening behind her, ensures that the figure stands out. I wanted to put in the

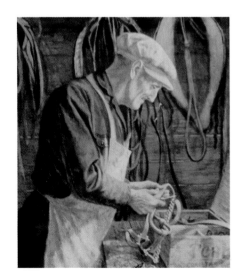

ABOVE The Saddler;
acrylic; 254 x 203mm (10 x 8in);
by Tony Paul.

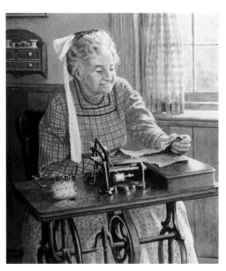

ABOVE The Seamstress;
acrylic; 254 x 203mm (10 x 8in);
by Tony Paul.

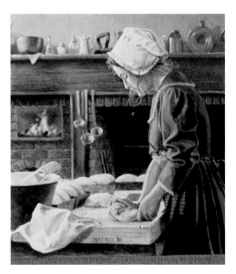

ABOVE The Cook;
acrylic; 254 x 203mm (10 x 8in);
by Tony Paul.

items on the mantelshelf as they helped reinforce her trade, but I was careful not to make them too important in case they drew the eye too much or jumped forward out of plane. The folds of her dress had to be painted carefully with half-lights on her front and half-darks acting as the light areas on her back. The darkest area of her dress is where the skirt sits in the shadow of the wooden block on which she kneads the dough.

The paintings sold quickly to one collector, who asked for more "people at work" paintings to make the set up to six. I used local tradesmen, the first of which was a blacksmith. This was a tricky subject as there were two strong sources of light – natural light coming through the open door to the left and the light of the forge itself. Looking carefully I noted that the daylight was slightly brighter and so I made sure this read as such.

If you look at the blacksmith's leather jacket you can see that the light on the left-hand side is lighter than that shining on the right. In addition, the relatively cool hue of daylight is contrasted to the warm orange of the forge's glow. In company with the other subjects in the series the composition remained simple, with a fairly flat background showing items relating to his trade.

The violin maker is shown measuring the thickness of the violin top that he is forming. On the block in front of him are wood shavings and two shoe-shaped planes that he is using to hollow out the instrument's curves. Again, the light is frontal, but this time there is only a hint of reflected light on his back. This is no showplace

workshop, as can be seen by the layers of dust on the old anglepoise lamp and the clutter. Around him are repairs, tools, pieces of violins, cases and wood shavings.

He has a well-defined facial structure and the light has modelled it beautifully, making my job fairly easy. I really enjoyed painting the thick, grey jumper and grubby, stained apron. I particularly liked working on the pocket area of the apron (near the vice handle), where he had wiped the fiddle varnish from his hand, leaving a clean area just above the rim of the pocket's top edge. Light was also important in painting the man's hands, careful observation being needed to make sure the tone of each change of plane in the fingers was accurately portrayed.

My final study for the series was of a shoe repairer. His was a somewhat shabby little shop, with walls of cracked and peeling paint, the characteristic layered dust and aroma of glue, rubber and polish, but well lit by a large plate glass window. I love painting cloth and it is interesting to see how the different cloths worn by the figures have been represented. The shoe repairer's shirt is of cotton, thinner than all of the other materials, with sharper accents of light and shade and an almost translucent character. Compare this with the worn, black leather apron he wears and the waistcoat that underlies it. The transitions between dark and light on these are much more rounded. Again the hands are important – see how the light alters with each change of plane at the joints of the man's fingers.

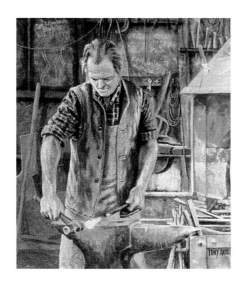

ABOVE The Blacksmith;
*acrylic; 254 x 203mm (10 x 8in);
by Tony Paul.*

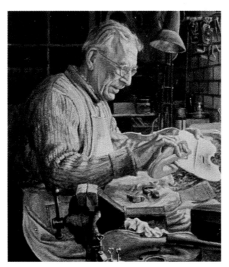

ABOVE The Violin Maker;
*acrylic; 254 x 203mm (10 x 8in);
by Tony Paul.*

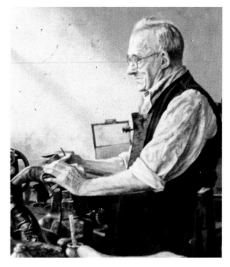

ABOVE The Shoe Repairer;
*acrylic; 254 x 203mm (10 x 8in);
by Tony Paul.*

LIGHT IN LANDSCAPE

Landscape has a long tradition as the most popular subject for artists. Looking at most landscape paintings it could be said that the effect of light is the real subject, with the landscape its vehicle.

Dull, overcast days are the bane of the landscape painter (see right). There is very little modelling on the landscape and colours tend to blend rather formlessly into one another. In these circumstances it is probably better to do a line drawing of the subject and leave it at that, perhaps to return when the sun puts form into the scene. If you look at this view of a quiet village road you can see that it does look dull. The trees form a flat homogenous mass and, although the ancient alms-houses are interesting, they too are practically formless.

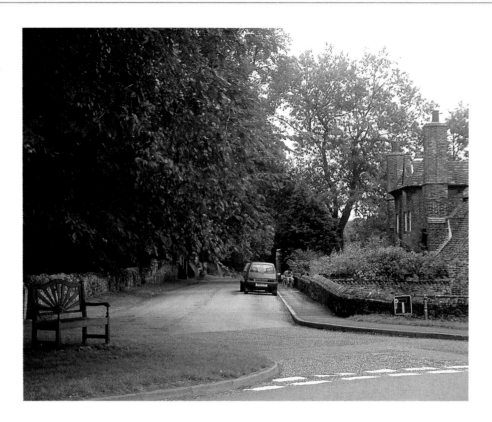

What a difference a little sun makes. Light has put distance and definition into the trees, the greens softening as they recede. They cast shadows over the wall and into the road, punctuating the otherwise broad expanse of grey. The building too, is transformed. Strong shadows give form to the roofs, gable ends and tall chimneys, and the dark of the long wall is a strong recessive element. The cars? Well, they're a feature of so many landscapes nowadays. If you are working on the spot, you can leave them out by moving beyond them so that you can see what lies behind. If you are working from a photo like this you could imagine what might lie behind or turn the car into a tractor, horse and cart, people walking along etc.

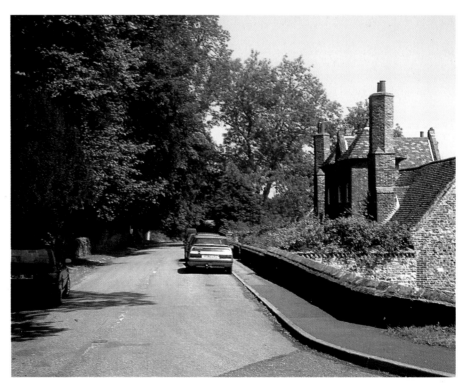

Good landscapes should have a strong sense of structure, a focal point and an effect of the fall of light. In the snow scene *Back Road, Essex, Massachussetts*, painted in acrylic by Denis Pickles, you can see all these effects come into play. The eye is led up the hill to the houses at its crest. These appear solid, lit by a bright sun, with considerable reflected light in the purplish, shadowed side of the houses. A similar reflective quality can be seen in the shadows on the snowy banks bordering the road. I like the warmth of the orangey trees – a good foil against the purplish-blue of the snow. The dark verticals of the trees frame the focal point – the brightly lit gable end of the house – beyond the crest of the hill.

ABOVE Back Road, Essex, Massachussetts;
acrylic; 406 x 508mm (16 x 20in); by Denis Pickles.

The pastel *Delphi, Greece* by George Thompson has a tremendous sense of scale and distance. The rough grasses, broken walls and columns in the foreground give way to dark, needle-like cypresses in the background. By the change of tone, a slight cooling of the colour and reduction of tonal contrast, you are aware that the land drops steeply away beyond the fence of trees. What you can see above the trees is a long distance away. George has softened the grey of the sweeping hill as it goes into the distance, the warmth of the steep hill on the left clearly cutting in front of it and plunging into the valley.

ABOVE Delphi, Greece;
pastel; 356 x 508mm (14 x 20in); by George Thompson.

A blend of ochre, green and burnt sienna in the buildings combine to create the warm light in *Summer in the Forest* by Eric Bottomley, while the hint of orange in the bridge and the touch of red in the boat bring an element of warm light and colour to the snow scene *Old*

Dee Bridge in Winter by George Thompson. *Canal Morning* by Gregory Davies, shows a slightly less structural image, but one full of light, heat and colour with a deep-blue reflected sky.

ABOVE Summer in the Forest;
oil; 762 x 1220mm (30 x 48in); by Eric Bottomley.

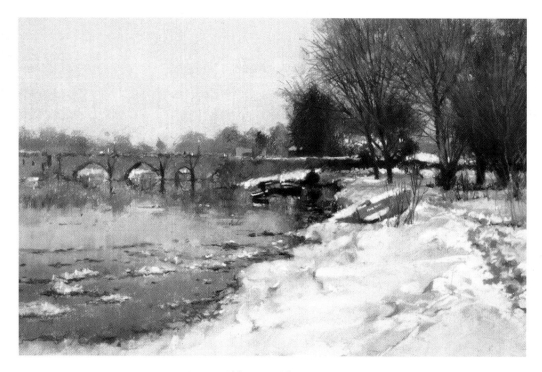

ABOVE Old Dee Bridge in Winter;
pastel; 356 x 508mm (14 x 20in); by George Thompson.

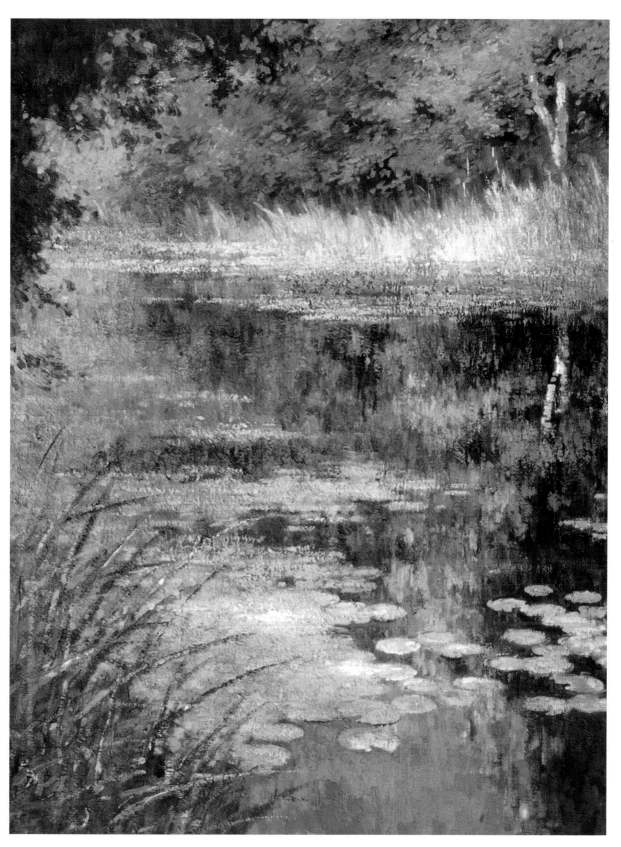

ABOVE Canal Morning;
oil; 762 x 610mm (30 x 24in); by Gregory Davies.

Shadows

Where there is light, usually, there will be shadows. And the stronger the light, the more pronounced the shadows, often giving form to solid objects and anchoring them to the ground. Shadows can also be useful to place lit subjects against, or to add drama or an air of mystery to an image. They can also give a sinister touch.[1]

It is important that shadows appear transparent, otherwise they will not read as shadows, but will look more like a solid object or dark carpet. At its most basic form, a shadow is little more than a lack of light, due either to a change of plane where light falls less fully on a surface, or where something has come between the light source and the surface on which the light falls.

Only in the case of bright, but narrow, light sources will the shadows be dense and black. Usually light will bounce off other surfaces, or down from the sky, putting a little light, and therefore colour, back into the shadows. An excellent example of this is Richard Bell's watercolour *York Goes Continental*. Here, the darks make the lights light and there is almost blinding light reflected from the quayside. The shadows, full of reflected light and probably made from a mix of Indian red and ultramarine, are crucial to the success of this painting. The shadow of the building defines the edges of the alfresco diners, and their shadows give the figures a real sense of solidity. The shaded dark of the quay wall completes the scene. Richard has put patches of light on the heads and shoulders of the figures, counterpointing them with more shadowy areas. See how solid they appear. He has also softened the contrast in the figures and shadows as they go back into the picture. This enhances the feeling of recession and reinforces the brightness of the quayside.

Although more complex, George Thompson's watercolour *Northgate Street, Chester* uses shadows to give solidity to forms and to help the figures read. Again, there is a good feeling of recession – see how less defined the buildings are at the far end of the street compared to those on the left. You are well aware that there is a considerable distance between them. Light, reflected from the sunlit buildings, lightens the tone of the dull purple of the shadows across the road and the figures in full light almost glow with brightness. Those within the shadows are more subdued - compare the brightness of the large, white figure on the left with the smaller, white-dressed woman to the right of the black-jacketed man.

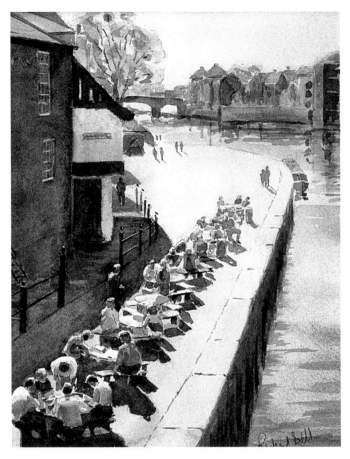

ABOVE York Goes Continental;
watercolour; 240 x 190mm (9 x 7½in); by Richard Bell.

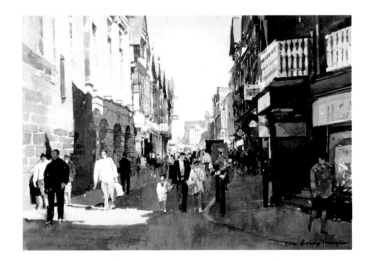

ABOVE Northgate Street, Chester;
watercolour; 178 x 356mm (7 x 14in); by George Thompson.

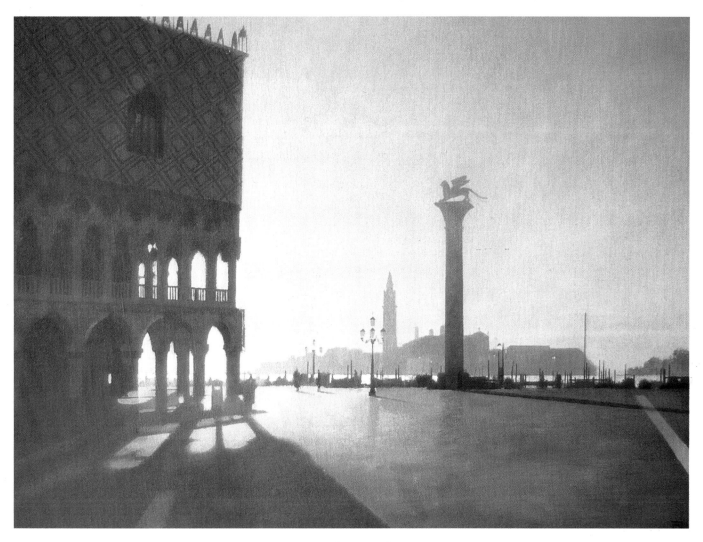

ABOVE November Morning, Venice;
oil; 279 x 381mm (11 x 15in); by Peter Kelly.

Shadows are very important in Peter Kelly's oil painting *November Morning, Venice*. The low winter sun; hidden behind the decorative arches of the Doge's Palace, casts its light through them, creating a powerful perspective and a sense of drama to what would otherwise be a fairly ordinary and tranquil scene. The strong light in the sky gradates into darker tones as it goes from left to right and you are aware of the relative distances of the painting's elements by their tone – the Doge's palace is the nearest and most distinct, while the column with the winged lion is further back and greyer, clearly reading against the yet paler silhouette of St Georgio over the water. Despite the darkness of the scene and the drama of the shadows, they are not black but have the dull glow of reflected light in them.

ABOVE La Place des Martyres de la Resistance, Aix-en-Provence;
watercolour; 203 x 305mm (8 x 12in); by Rod Jenkins.

There is a terrific feeling of light within the shadows in Rod Jenkins's watercolour *La Place des Martyres de la Resistance, Aix-en-Provence.* Here, bright sunlight filters through the trees to scatter the walls of the buildings with comet dashes of light. Rod could have chosen to step down the tone so that the ground, the sunlit walls and the sunlit sides of the planters were in their local colours, but he felt that it might have looked dull. Instead he chose to show the power of the Provençal light by bleaching out the light areas and creating a variety of colour in the shadowed areas. The intensity of the light, where it penetrates the shadows, is almost blinding. I love the changes of colour within the basically greyish shadowed areas – here greenish, where it is close to overhanging foliage, here bluish, here yellowish, here orangey. I like the cool neutral grey of the footpath and the way that the texture of the pebbled surround in the paving by the tree is suggested – lit areas left white and straight shadows cast by the planter corrugating as they pass over the stones.

PART FIVE
LIGHT TECHNIQUES IN
VARIOUS MEDIA

Watercolour

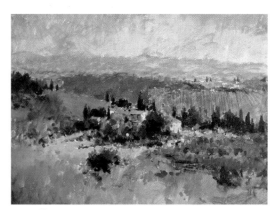

Gouache

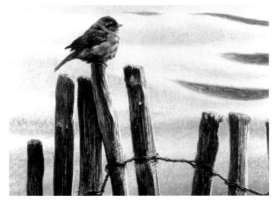

Tempera

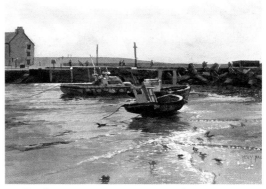

Acrylic

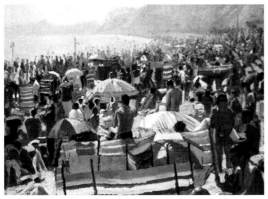

Oil

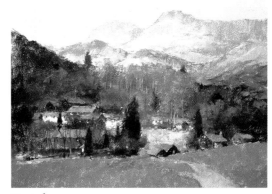

Pastel

WATERCOLOUR

The natural transparency of thin watercolour washes is useful in creating a sense of light. The light is reflected from the paper, making colours glow. Often the paper is left unpainted for the ultimate lights, while rich darks provide the contrasts.

Strong light is portrayed in the watercolour *Barcelona Café* by George Thompson: cold, darkish greys alternate with warm, light ochre colours to give a feeling of strong sun. The figures within the shadows on the right are almost silhouettes, yet there is colour in them. See how dark their faces have been painted in contrast to the flesh tone of the waiter's face. I love the effect of light shining through the sunshades – perfect in terms of tone – it really glows.

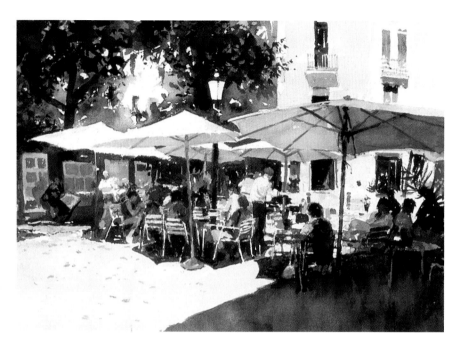

ABOVE Barcelona Café;
watercolour; 254 x 355mm (10 x 14in); by George Thompson.

Portraying light on water was my aim in the painting *Preparing Gondolas, Venice.* I loved the way that the colours and tones of the reflections changed depending upon what was being reflected and how the light changed on the old buildings lining the narrow canal. The transparency of the medium was a great help in achieving many of these effects.

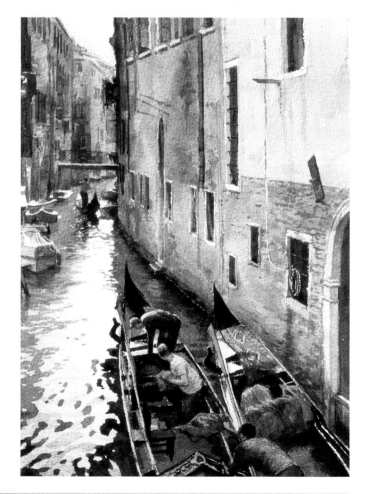

RIGHT Preparing Gondolas, Venice;
watercolour; 381 x 305mm (15 x 12in); by Tony Paul.

GOUACHE

Gouache, sometimes known as "designers' colour", or "body colour" is really opaque watercolour. Unlike standard watercolour, light colours can be applied over darker ones, obliterating what is underneath.

Low Tide, West Bay was painted on a handmade turner blue paper. Although straightforward, semi-transparent washes were applied with dilute gouache to the boats, the quays and the house with the beach beyond, the sky, the foamed edge of the water and the highlights on the boats were made with opaque colour applied fairly densely. The blue-grey colour of the paper has been allowed to show through, particularly in the water, much of which has only the slightest of washes. (White gouache is often used by watercolourists who have accidentally lost, or painted over, their highlights.)

RIGHT Low Tide, West Bay; *gouache; 279 x 254mm (11 x 10in); by Tony Paul.*

In *Last of the Windfalls* the chair was blanked out with masking fluid then cool, dark green washes were applied to the background, with warmer and paler washes for the sunlit grass. Further washes were applied to modify the colours and the chair and hat were worked on. Purple-grey was used to indicate the solid frame of the chair, while lighter colours gave an effect of light passing through its back. The texture of the grass was built up using small opaque strokes of a lighter tone and the apples put in. Finally, the overhanging branches were painted using various tones and hues of opaque green to reinforce the effect of strong light.

RIGHT Last of the Windfalls; *gouache; 279 x 305mm (11 x 12in); by Tony Paul.*

EGG TEMPERA

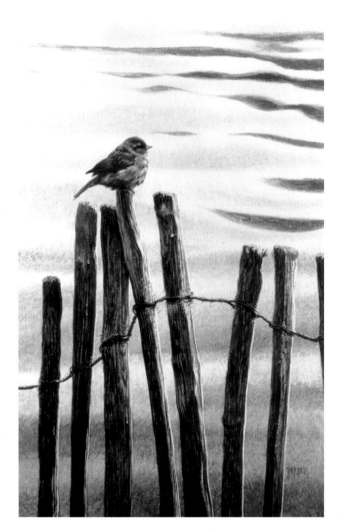

This medium is translucent and it dries quickly. Instead of blending the colours, which is almost impossible, they are applied thinly in small touches, overlays or crosshatchings.

The contrasts in the painting *Winter Sparrow* are quite stark, the puffed up bird being seen against the gently rippling water of a lake. See how the half-lights and half-darks have been used in the chestnut palings and the female sparrow's plumage. The general colouration of the painting is cool to reflect the season.

LEFT Winter Sparrow;
egg tempera; 355 x 254mm (14 x 10in); by Tony Paul.

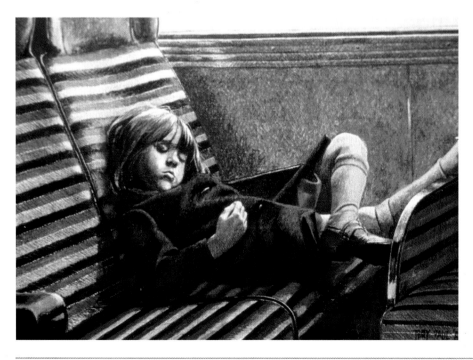

The small touches of paint are clearly evident in *Asleep on a Greyhound Bus*. Kerry (my daughter) was bathed in a fairly low, raking light, and the shadows were quite dense. I worked hard at putting some light into the shadows to avoid them looking dead. I enjoyed putting the reflection of the light into the aluminium edging to the window, and in representing the chrome edging of the armrest on the adjacent seat – all careful judgements of tone.

LEFT Asleep on a Greyhound Bus;
*egg tempera; 254 x 355mm (10 x 14in);
by Tony Paul.*

ACRYLIC

Acrylic is an extremely versatile paint, capable of thick or thin applications. Its quick drying capabilities can be used to effect when overlaying several layers of paint as demonstrated in the *Portrait of Brian*.

I put in the shadows first in a fairly loose way with dilute paint then applied the lights using more density in the colour. Wash over wash of translucent colour was used to modify the underlying hue until a strong feeling of form was obtained. Owing to the thickness of Brian's glasses the eyes were not at all clear, so I painted what I saw, rather than what I knew to be there. I enjoyed painting the nose – its edge is lost against the rim of the glasses, which somehow gives it a strong sense of realism. The "ticks" of white added sparkle to the final portrait.

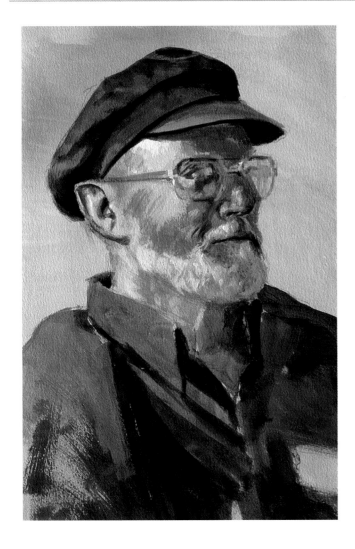

LEFT Portrait of Brian;
acrylic; 558 x 381mm (22 x 15in); by Tony Paul.

George Thompson's *Tuscan Landscape* is very different. An apparently quick, fresh impression, he has used the paint in an opaque, rather than a translucent way, more in the manner of an oil painting. See how bands of different colours and tones have been used to give recession – right up to the distant horizon – the contrasts softening and becoming cooler as they recede. The sharp light of the walls of the buildings, contrasted to the dark cypresses, draws the eye and becomes the centre of interest.

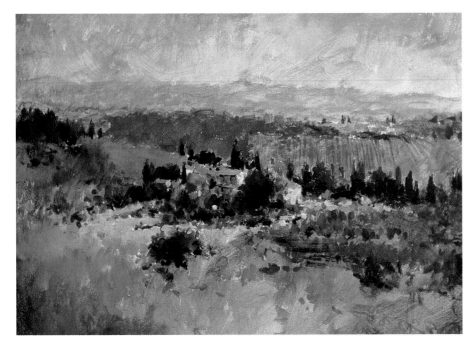

LEFT Tuscan Landscape;
acrylic; 406 x 508mm (16 x 20in);
by George Thompson.

OIL

If you need a wide tonal range in your painting, then oil paint is the medium for you, particularly if there is a dark tonality to the subject. No other painting medium can achieve the cavernous darks that can be seen in most old master oil paintings.

Leaving the Bedroom has an air of mystery about it. The sharp contrast between the sonorous, angular darks and the delicately coloured lights is a characteristic of Peter Kelly's work. The former are worked in the traditional way with layer upon layer of transparent glazes of colour, while the latter are sometimes created with scumbles of pale colour applied over darker ones. A tremendous depth of tone is achieved in the darks, while the lights are not stark but have a soft quality. The tonal range of this painting is simply of four tones – the door opening is a light tone, the sheet a half-light, the figure a half-dark and the room interior a dark.

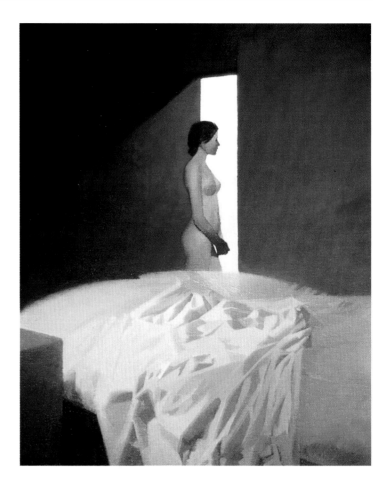

RIGHT Leaving the Bedroom; *oil; 508 x 355mm (20 x 14in); by Peter Kelly.*

Bournemouth Beach – High Summer could hardly be more different. A strong, saturated kaleidoscope of colours was needed to describe the hot buzz of this packed beach. I had to be very careful to adjust tones and colours so that they read clearly against one another. Although most of the bottom half of the painting is formed by recognizable people, sunshades and windbreaks, beyond this I painted what I saw – a patch of red here, a little dash of blue there, and so on, without trying to rationalize what they represented. See how the colours become less saturated as they recede into the heat haze in the distance.

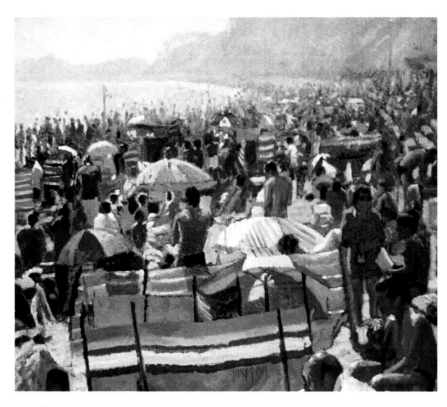

RIGHT Bournemouth Beach – High Summer; *oil; 254 x 305mm (10 x 12in); by Tony Paul.*

PASTEL

Pastel requires a different approach than wet media. Colours cannot be pre-mixed on a palette but have to be blended or overlaid on the painting's surface. An advantage is that colours rarely become muddy from over mixing, but retain a clear, vibrant quality.

George Thompson's *Elterwater and Langdale Pikes* is a sparely painted pastel exploring the many grey and neutral colours in the subject. The sun is weak and the colours are therefore muted, but he has managed to bring life to the subject. Pastels are quite fast to apply but a fair bit of experience is needed to know which colours work well together. I love the use of the pink terracotta beneath the central band of trees, in contrast with the dull greens. Again, see how the view to the distant "pikes" has been divided into separate bands of tone and colour, the contrasts softening as they recede.

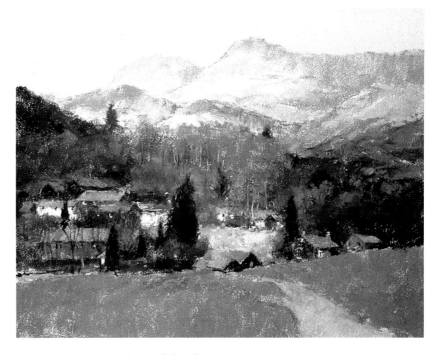

ABOVE Elterwater and Langdale Pikes; *pastel; 406 x 508mm (16 x 20in); by George Thompson.*

Rose Cluster by Linda Patterson shows how important light is when painting flowers. Despite being painted in pastel, the most opaque of media, the petals appear translucent, with the light seeming to pick up rich colour in the depths of the flower heads. You are in no doubt as to the direction from which the light is coming because the petals in the shadowed side of the heads have been painted in lower-toned, cooler colours. I like the way Linda has subdued the bursting buds beneath the main rose head, putting them into the shadows. Note too, the looser and reduced contrast of the background blooms, which pushes them back into the picture and helps with a sense of depth.

RIGHT Rose Cluster; *pastel; 229 x 178mm (9 x 7in); by Linda Patterson.*

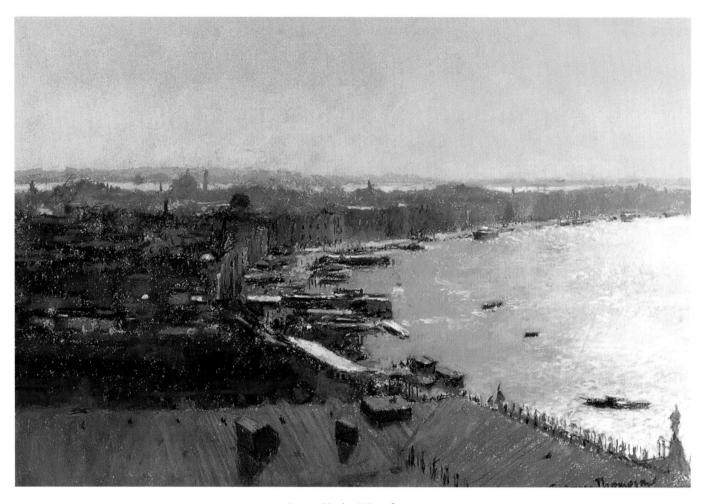

ABOVE Venice Waterfront;
pastel; 355 x 508mm (14 x 20in); by George Thompson.

Venice Waterfront by George Thompson is a superb example of the use of light in a painting. Viewed from the bell tower of St Marks and looking over the roof of the Doge's Palace, it shows a panorama that offers a view beyond the lagoon to the Lido in the far distance. Monet once said, "When you go out to paint, try to forget what object you have before you – a tree, a house, a field, or whatever. Merely think – here is a little square of blue, here an oblong of pink, here a streak of yellow, and paint it just as it looks to you, the exact colour and shape, until it gives your own naive impression of the scene before you." George does this admirably in this painting.

It would be impossible (and boring) in such a panorama to detail every building, but the eye rarely takes in the detail of all it sees and an impression is really all that is needed to imply what is there. A strong, low light strikes horizontal structures here and there (probably roofs) and odd dashes of colour – greens and orange/pinks – indicate other structures. There is implied detail throughout the painting, but on closer inspection the detail is merely a suggestion of shape and tone and this is all that is required. Again, there are the lights of the water, sky and roofs, the half-lights of the palace roof and distant landscape, the half-darks of the buildings and the darks that act as punctuation throughout the painting and, particularly, in the impossible tangle of roofs in the left-centre of the work. The colour is very restrained, consisting mainly of off-greys, but with an overall peachy glow.

PART SIX
DIFFERENT KINDS
OF LIGHT

SUNSET

Sunsets are a popular subject, often chosen because of their relative simplicity. Apart from the colour of the sky, which is the source of light, the other elements are much reduced in both tone and colour, sometimes even appearing as mere black, or near black, shapes.

The Iron-Age fortified settlement of Maiden Castle in Dorset is a massive earthworks. In Ronald Jesty's watercolour it is reduced almost to silhouettes, and where the crests of the ramparts cut into the sky they read as one. Ron has indicated the scale of the castle by including three figures on the ridge of one of the ramparts, silhouetted against the pink of the cloud-striped sky. The darkness of the castle, by contrast, fills the sky with light, the long horizontals bringing a feeling of calm to the scene.

BELOW Maiden Castle;
watercolour; 114 x 311mm (4½ x 12¼in); by Ronald Jesty.

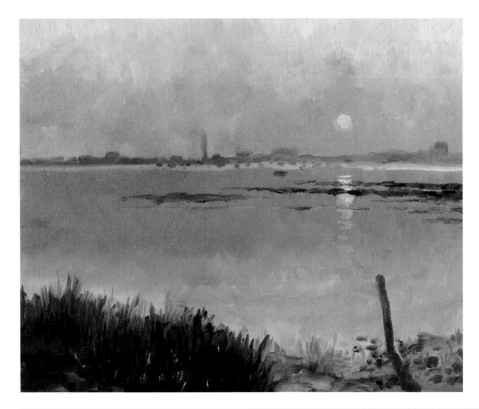

My oil *Sunset, Poole Harbour* is a simple sketch relishing the beautiful end-of-day colours. The distant shoreline is a half-light in tone while the salt marsh and foreground are half-darks. The sea absorbs some of the reflected light of the sky and so is slightly darker, but the setting sun's reflection is crisp. Dark accents are used here and there to punctuate the mid-tones.

LEFT Sunset, Poole Harbour;
*oil; 254 x 305mm (10 x 12in);
by Tony Paul.*

LAMPLIGHT

ABOVE The Rehearsal;
oil; 355 x 584mm (14 x 23in); by Peter Kelly.

The kind of light that a lamp provides will depend on how it is projected or diffused. A lamp with a reflector or shield – such as a spotlight or anglepoise, will give a sharp, narrow beam of high intensity light. Entirely different is the character of a table or ceiling light – designed to be diffused in all directions by the shade.

In Peter Kelly's *The Rehearsal* almost all the light comes from the single anglepoise lamp that the pianist is using to illuminate her music. Although this is a fairly directional light, there is enough residual light reflected off the music, the wall and the piano to illuminate the remainder of the room dimly. The areas immediately around the lamp are quite brightly lit but the light decays quickly into a transparent dark that has hints of bounced light.

The character of the light in my *Lamplit Figure* is slightly different. The opal shade of the lamp is designed to spread a softer, more even light to a fairly wide area, but as the size of the lamp is fairly small, its decay, although not as sudden as with the anglepoise, is still marked. The areas of flesh turned towards the lamp are brightly lit – almost bleached out – while those that are turned away from the light are very much darker in tone yet, again, have the benefit of some reflected light.

LEFT Lamplit Figure;
egg tempera; 508 x 610mm (20 x 24in); by Tony Paul.

REFLECTED LIGHT

Without reflected light things would look very stark, with heavy, dark shadows and bright lights. Reflected light puts colour and life into shadows, softening them and often revealing forms within them.

The watercolour *Garlic Pot* by Ronald Jesty has some wonderful examples of reflected light. See how he has emphasized the changes of plane in the side of the pot: on the right-hand side of the shoulder and lid the grey is quite dark, with distant light reflected from the ceiling; yet, in the vertical planes of the neck and side, the colour is much lighter, with light reflected from the white cloth. There is even a suggestion of the pot's glossy surface. The opened garlic head casts a pinkish light on to the shadow side of the unopened one, with coloured light reflected from the brownish clove. See how the white of the undercloth becomes greyer in the area behind the pot – an effective way of giving the subject a sense of perspective.

ABOVE Garlic Pot;
watercolour; 292 x 330mm (11½ x 13in); by Ronald Jesty.

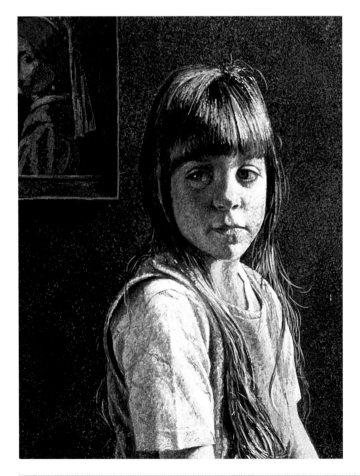

Reflected light also has a role to play in portraits. In the tempera portrait *Julie and the Pearl Earring*, reflected light has softened what could have been a fairly harsh lighting effect on the model. The light into the shadow side of her face is being reflected from the shoulder of her T-shirt, putting very necessary form into her eye, nose and mouth, and emphasizing her cheek as it turns into the side of her face.

Where parts of her face – the cheek directly beneath the eye, the ridge of her nose and the corner of her mouth – were turned away from the light, the shadow remains darker.

LEFT Julie and the Pearl Earring;
egg tempera; 254 x 203mm (10 x 8in); by Tony Paul.

EVENING LIGHT

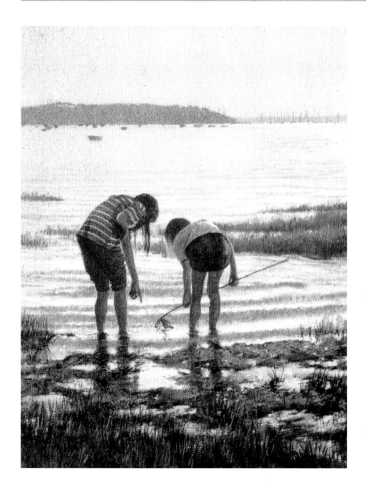

As the sun sinks towards the horizon in the late afternoon the light changes. Shadows elongate and the power of the sun diminishes, its light becoming warmer. This often creates an overall yellowish cast on landscape elements and, with the lowness of the sun, sharp changes of tone sometimes occur.

The tempera painting *Looking for Mini-beasts, Poole Harbour* is set at this time. The light is warm with the humped form of Brownsea Island little more than a silhouette. The figures, too, are losing some of their colour and becoming defined shapes against the light.

LEFT Looking for Mini-beasts, Poole Harbour; *egg tempera; 406 x 305mm (16 x 12in); by Tony Paul.*

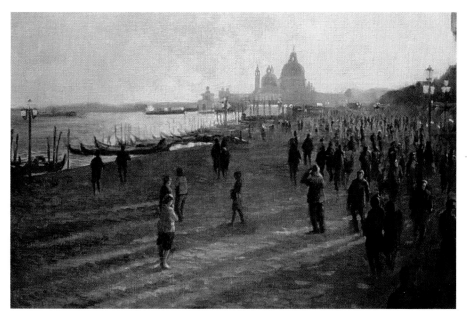

In the oil painting *The Salute from the Ponto Delle Paglia, Venice* the evening has advanced a little, with seriously long shadows and dimming light. The Salute is hazy in the background, while the promenade is cool in colour in the shade, with warm light cutting across. The people are silhouettes except where they interrupt one of the beams of raking light. I added little sparks of light that I saw here and there in the background. I don't know what they are reflected from, but they help to punctuate and give interest to the distance.

ABOVE The Salute from the Ponto Delle Paglia, Venice; *oil; 457 x 711mm (18 x 28in); by Tony Paul.*

INTERIOR LIGHT

The factors that create certain lighting effects within a room will depend on the following: the strength and direction of light coming through the window, the size of the window, the number of windows, any additional artificial lighting, the size and shape of the room and the tone and colour of the walls.

The main source of light in the pastel *Students at Work, Kingcombe Centre* is the large window in the background, but there are other windows adding to the light and making it more even. The figures at the far end of the tables are against the light more strongly than those that are nearer. See how important the light is around the profile of the balding man in separating him from what is behind him. The background is busy, with a dark piano and an amount of clutter on a table, but I have treated everything here as a series of simple shapes, ensuring that the main subjects, the figures, read well.

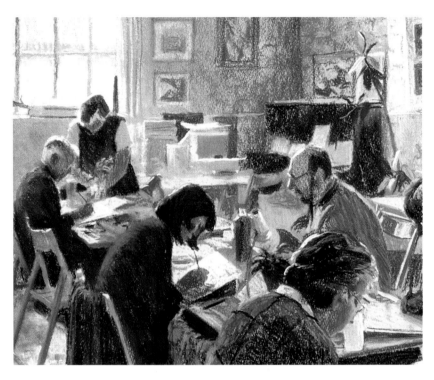

ABOVE Students at Work, Kingcombe Centre;
pastel; 250 x 380mm (10 x 15in); by Tony Paul.

The sole source of light in my tempera of *Thomas Hardy's Cottage* is the window. If you peer through your eyelashes, light does seem to be coming in through the window. Although the walls appear to be fairly pale, they are, in fact, considerably darker than what lies outside the window and even the white counterpane on the bed is darker than "outside". Remember to paint things as they appear to be in relation to one another, rather than how you know them to be.

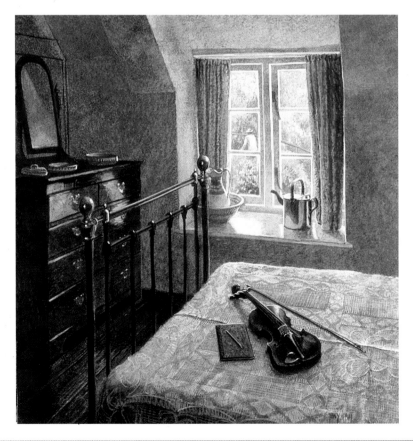

RIGHT Thomas Hardy's Cottage;
*egg tempera; 356 x 254mm (14 x 10in);
by Tony Paul.*

CONTRE-JOUR

Contre-jour means "against the light", with the light coming towards you. It can be very uncomfortable to work with the light in your face and difficult to see well enough into the shadows to read what is there. However, there are many artists who favour painting into the light and the work they produce is usually strong in form and tonal structure.

As a painter looks into the light, everything that comes between him or her and the light source will have its shadow side facing him, so the focus will tend to be tone, rather than colour. In the water-colour *Portland Bill, Looking Eastward* Ronald Jesty has painted a very strong image of the rocky coastline. The obelisk stands out strongly against the sky, but is softened by distance. See how, in contre-jour, the edges of some of the rocks are strongly lit, while planes that are turned away are very dark, particularly where they are closest to the source of light. The painting is almost a monochrome with reflected light playing its part in lightening the shadow tones of some of the rocks. The silhouetted figures give scale to the landscape.

ABOVE Portland Bill, Looking Eastward;
watercolour; 203 x 279mm (8 x 11in); by Ronald Jesty.

In the tempera *Bottles, Begonias, Taps and Twiggy* Twiggy the cat sits almost in silhouette against the light coming in through the window. The vertical of the window frame was white but, because it is contre-jour, it appears darker – almost as dark as any of the elements outside the window. I have tried to capture the reflected light in the stainless-steel sink top and taps.

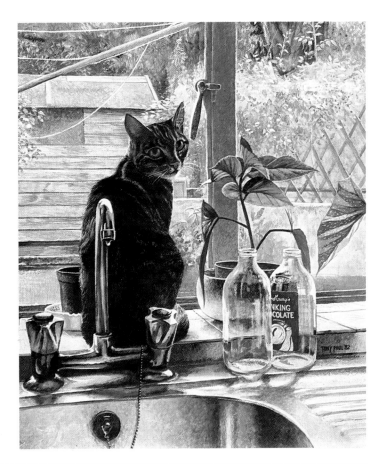

RIGHT Bottles, Begonias, Taps and Twiggy;
egg tempera; 407 x 305mm (16 x 12in); by Tony Paul.

DULL DAYLIGHT

An age-old question asks: What do you get when you paint on dull days? The answer being dull paintings. Often this can be true, but it really depends on what the subject is, and also how it is treated.

My little oil *Bournemouth Beach, Rainy Day* was begun with great enthusiasm, but as I painted I became dispirited at the blandness of the blue-greys and ochres and the lack of light. I was thinking of giving up when I heard the sound of voices behind me. A couple walked by holding a coloured umbrella and it was just what the painting needed, both as a necessary touch of colour and to emphasize the deserted quality of the out-of-season beach. It is strange, but often a single figure, or in this case two closely linked figures, can give a greater feeling of desertion than a scene totally devoid of people.

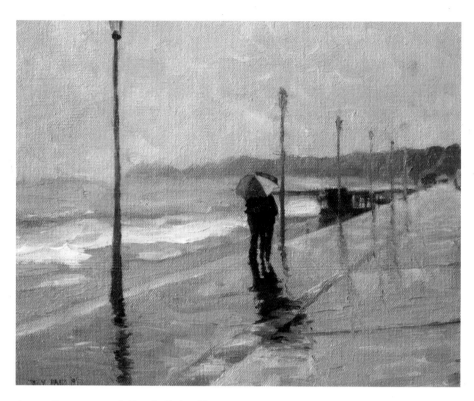

ABOVE Bournemouth Beach, Rainy Day;
oil; 254 x 305mm (10 x 12in); by Tony Paul.

Colour is not so important in my acrylic *Westminster*. The light is clear and the buildings are sharply defined against the sky. A great deal of interest and texture has been put into the painting – from the shingle of the Thames at low tide and the man repairing his beached boat, to the barges and pleasure boat, and the architectural elements of the Houses of Parliament and other buildings. The light is fairly flat with little tonal variation in the different planes of the buildings. On reflection I feel that despite its interest and attention to detail, the painting is still a little on the dull side.

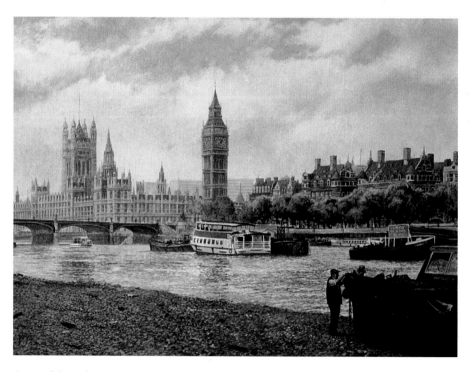

ABOVE Westminster;
acrylic; 508 x 762mm (20 x 30in); by Tony Paul.

FULL SUNLIGHT

Full sunlight will create the brightest colours and deepest shadows. But these shadows will often be softened by reflected light from sunlit buildings and by the ambient light from the sky. In painting terms a subject with full sun will require the artist to use a full tonal range and bright colours in his painting.

St Ives, in Cornwall is renowned for its light. In his oil painting *Windbreaks at St Ives* Bob Palmer has caught the saturated light of the summer beach. The colours are clean and brightly primary, applied in a lively and expressive way. The figures are against the light, painted in fairly dark tone, just as they would appear. See how the offset shadows of the right-hand figures are cast on the windbreak, revealing that the light is shining through its polypropylene fabric. The brightness of the beach – lighter than the sky – combined with the purity of the colours gives this painting its truth.

ABOVE Windbreaks at St Ives;
oil; 254 x 356mm (10 x 14in); by Robert Palmer.

The warm tone of the paper upon which George Thompson painted the pastel *Bridge Street, Chester* helps put light into the sky. He reinforces this with careful use of light and shadow to put form into the buildings. The creams and orangey browns used on the sunlit buildings on the right create a feeling, not only of light, but heat, while the hues on the shadowed buildings are both darker and cooler. Note just how strong the tonal contrast is where the light slices through the gap between the extreme left-hand building and its neighbour. The shadows across the road are fairly dark, yet appear to have reflected light in them – see how they step up as they meet the pavement on the far side of the road.

ABOVE Bridge Street, Chester;
pastel; 356 x 508mm (14 x 20in); by George Thompson.

SHIMMERING LIGHT

When strong light and heat combine they can create a shimmering light. Most often seen on water where it is fairly easy to represent, it can also be seen on the land in very hot temperatures. The light scintillates, breaking into specks of colour that seem to vibrate in the eye.

In my pastel *A Paddle Steamer Leaving Montreux* I have represented shimmering light by painting the scene using multi-coloured touches of pigment, often of similar tone, that blend in the eye to create the effect. This is most obvious in the water, but I have carried it through the whole painting. Each colour is composed of small touches of various light-toned but brightly coloured pigments.

ABOVE A Paddle Steamer Leaving Montreux; *pastel; 305 x 406mm (12 x 16in); by Tony Paul.*

I have encountered this shimmer in cornfields and meadows like those in the oil-painting *Cows, Evening Shadows* by Gregory Davies. Greg often paints using small touches of paint that are different colours but of the same tone. Here, the flecked yellows, pinks, purples, greens and blues, applied fairly texturally, mix in the eye to recreate the scintillating effect of heat haze in this meadow in the south of France. In Greg's painting a slightly hazy effect has been created by lightening most of the colours with white.

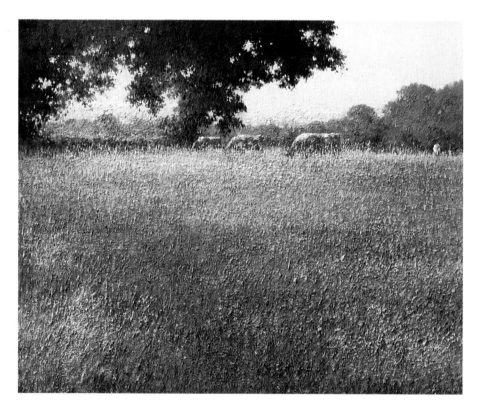

ABOVE Cows, Evening Shadows; *oil; 762 x 914mm (30 x 36in); by Gregory Davies.*

PART SEVEN
TONAL KEYS

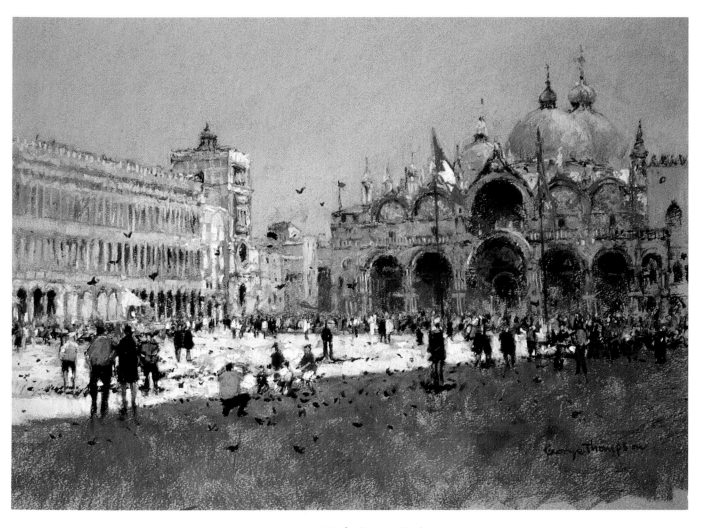

ABOVE St Marks Square, Venice;
pastel; 356 x 509mm (14 x 20in); by George Thompson.

HIGH-KEY PAINTING

ABOVE The Thames at Richmond, Early Morning Mist;
acrylic; 381 x 558mm (15 x 22in); by Tony Paul.

In many ways painting is like music, and this is particularly relevant in terms of tonal keys. Imagine a piano keyboard: its whole range runs from thin, tinkling high notes to sonorous, rumbling deep ones. Not every piece of music explores the complete range of the keyboard: some will limit themselves to its higher end, perhaps to imply a light, floating character, while others explore the deep tones that may have a magical, even menacing feeling. Sometimes, of course, the middle range is used, perhaps with brief visits to the deeper and higher tones.

The painter can create mood in a painting in a similar way, by varying its tonal range. High-key pictures are painted either using bold, saturated colours or ones that are soft and pastel coloured, slightly mystical in character – perhaps even romantic. Low-key or dark-toned paintings can be brooding, quietly calm, mysterious or sinister. Close-toned subjects have a very restricted range of tones. This is the most difficult kind of painting to pull off successfully, where every mark has to be carefully balanced against its neighbour.

Some paintings are high key simply because that is the natural pitch of the colour in the subject – Monet's paintings of Giverny or the Seine in the fog for example. In other instances a high key is used for an emotional effect. Watercolour paintings are often high in key, sometimes called "the string quartet", compared to the "symphony orchestra" of oil paintings. Although there are watercolourists who paint in low tones, they are in the minority. The very thinness and transparency of the medium tends to engender a light touch.

The Thames at Richmond, Early Morning Mist is an acrylic painted on oatmeal-tinted watercolour paper using a watercolour technique. The light was quite delicate, with an almost magical calm and vapidity – something I strove hard to capture. The darkest tone is a mid-tone seen at the base of the protruding bank on the left. To build up the landscape – making the sky's reflection a little darker than the sky itself – I used delicate purples, greens, blues and yellows thinly and sometimes with white added to counteract the yellowness of the paper. I saw the trees as appearing weightless, almost like puffs of yellow/green smoke, and tried hard to instil this quality into them.

ABOVE Mr Potter;
watercolour; 305 x 203mm (12 x 8in); by Tony Paul.

Mr Potter was a busker in my hometown. He always seemed to have a look of being somewhat bemused by life and it was this character I tried to catch. He had an amazing white beard, which joined up with his hair to give an extraordinary shape to his head. I made this quick study in watercolour. The whole effect is quite light and uses only three colours – manganese blue, raw sienna and permanent rose – none of which have a dark mass tone. Even where all three colours were mixed fairly densely – as for the frames of his spectacles – the tone is not very dark. Nevertheless, I feel that I have caught a feeling of light in his face.

LOW-KEY PAINTING

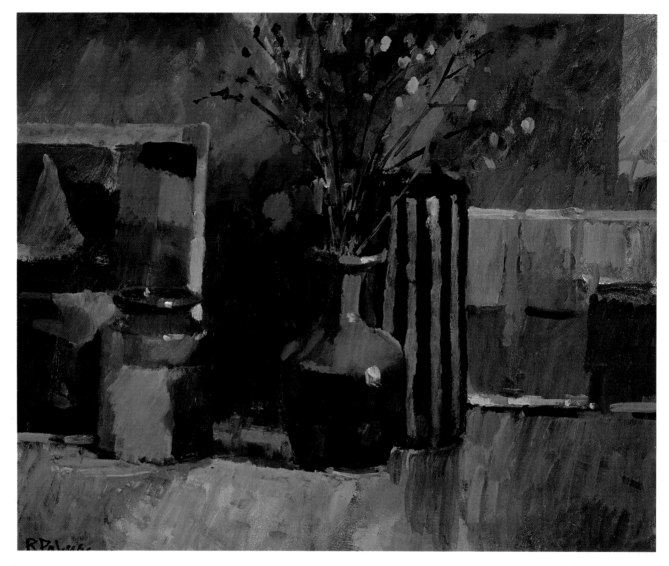

ABOVE Still Life with Striped Jar;
oil; 254 x 305mm (10 x 12in); by Robert Palmer.

With low-key work, care has to be taken that the colours are not too dull, otherwise a painting itself can become too dark and depressingly dreary to look at. Careful selection of deep-toned but clean-hued colours and mixes is essential in order to lift a painting. Naturally dark but vibrant colours should be used or, alternatively, higher-key colours can be scumbled thinly over darker ones, which tends to subdue their lightness of tone. The brightness of such colours works well against the more tertiary darks.

In his painting *Still Life with Striped Jar* Bob Palmer has used both scumbling of lighter colours and patches of deep-toned pigments to bring light to his low-key

painting. His sense of colour is wonderful. Based on a theme of the complementary colours, Bob has rejected the usual idea of placing colourful items against a neutral background by using neutral objects against a lively multi-coloured background, complete with postcards. I like the way that red earths, ochres and soft greens have been blended, and love the blue spot behind the little vase – I have no idea what it is meant to represent, but it doesn't matter, it sits perfectly against the rich red. The three pieces of pottery have been simply, but effectively, represented using restrained colour in tones that make them look very realistic. Yet this realism still works against the free, semi-abstract quality of the background.

A very limited range of colours was used in *Toll House – Dusk* by Ronald Jesty. The roof is reflecting the dwindling light from the sky and the remainder of the scene is painted in dark, but subtle, colours to capture the character and texture of the turbulent ground and dark trees. To remind us of just how dark the scene has become there is a stab of light from the lamp at the top of the pole by the cottage.

RIGHT Toll House – Dusk;
watercolour; 178 x 229mm (7 x 9in);
by Ronald Jesty.

I have tried to capture a moment of contemplation in *Awaiting her Cue*. The ballerina waits in the wings, the stray light from the stage catching her shoulder and the tip of her ear and, less strongly, the front of her leotard, the edge of her arm and her leg. There is also a hint of reflected light on her back. Although the colours in the figure may appear fairly subdued, this tempera was painted using almost pure ochres, pinks, blues, greens and purples applied in small touches.

RIGHT Awaiting her Cue;
egg tempera; 355 x 254mm (14 x 10in); by Tony Paul.

CLOSE-TONED SUBJECTS

Close-toned subjects are quite difficult to achieve successfully, simply because the closer together the tones are, the less contrast there is between them and potentially the harder they are to read, which means they have less impact. The hand painting the picture has to be very sensitive.

Close-toned subjects can be painted in any tonal key – high, low or using saturated colours. In my tempera *Low Tide, Poole Harbour* the key is very high and the colours very pale indeed. It is only the white of the sinking sun and its reflection in the pools and sea that gives the scene form. The challenge in this painting was to interpret the transparency of the water in the foreground and the perspective of the water-filled trenches left by the bait diggers. It was interesting to see how the foreground pool changed from a reflection of the sky to a view through the shallow water to the sand beneath. The diminishing scale of the sand ripples helped with the feeling of distance in the painting.

ABOVE Low Tide, Poole Harbour;
egg tempera; 457 x 355mm (18 x 14in); by Tony Paul.

In the step-by-step demonstration on pages 118–121 you will see Valldemossa painted using pastels. Although the demonstration shows a visual transcription of the town, I can remember it as being very hot and quite hazy, so this is more how it felt to be there at the time. Comparing the two paintings, this is the more literal one to me, where the tones of the subject are much closer.

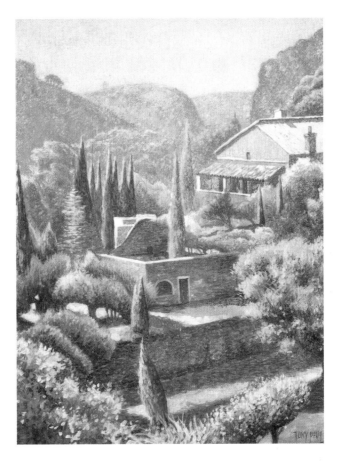

RIGHT Valldemossa;
egg tempera; 330 x 279mm (13 x 11in);
by Tony Paul.

In the acrylic *The Gondola, Venice* I have used a fairly saturated, close-toned palette. Many of the colours in this painting change temperature, giving form to the buildings, with the changes of tone quite limited. This way of working gives a strong image with good colour and demonstrates that a subject where colour, rather than tone, predominates, can also have great strength. It is certainly an alternative viewpoint to the tonal work I normally pursue.

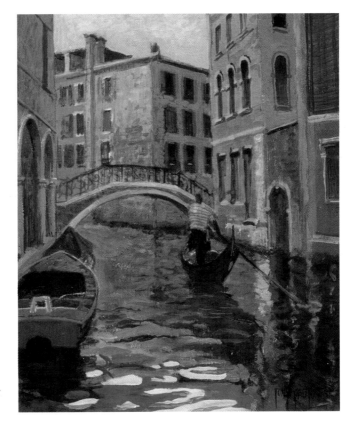

RIGHT The Gondola, Venice;
acrylic; 254 x 203mm (10 x 8in);
by Tony Paul.

FULL-TONED SUBJECTS

ABOVE Watching Squirrels;
acrylic; 406 x 305mm (16 x 12in); by Tony Paul.

For my acrylic *Watching Squirrels* a full range of tones was used – see how the contrasts vary. In the background the trees are fairly pale: note how light in tone and cool the trunk of the tree behind the main tree is and, again, how dark the tree roots are in the foreground as compared to those at the foot of the tree. The figures of the two girls are almost contre-jour, but light is reflected up from the ground to give gentle modelling to the side of the nearer girl's dress.

PART EIGHT
DEMONSTRATIONS

A Corner in Water-soluble Coloured Pencil by Tony Paul

Coloured pencils are not as easy to use as you may think, and can give weak, thin results in the hands of the inexperienced artist. In fact, they need to be used robustly if they are to be effective. Pressure, sometimes quite hard, is needed to get a good strength of colour and tone. Using water-soluble pencils helps and reduces the need for hard scrubbing, because the heavily applied colour can be wetted to fill the grain of the paper. For the best results, use a tough-surfaced paper together with a hard surface such as a drawing board. Leaving the paper in a pad will make getting dense colours difficult and the pressure is likely to dent the paper and some of the sheets beneath.

The subject here is a corner of a wonderful house and garden, "Rymans", in West Sussex. It was quite a challenge as it contains strong changes of tone as well as colour.

Stage 1: I began by taking a sheet of Canson "C" grain paper – a paper with a textured and fairly hard surface – and made a careful drawing of the subject using a 2B pencil. I took time to get the perspective of the building right and indicated areas of dark tone with a little shading.

Stage 2: Using a dull violet water-soluble pencil, I worked in all the dark and middle tones. I pressed quite hard in places but didn't fill the grain of the paper completely (see detail). When this was done I worked over the greens using warm, cool, light and dark green pencils, and added touches of yellow, orange, blue and brown, with the cooler colours going into the shadow areas.

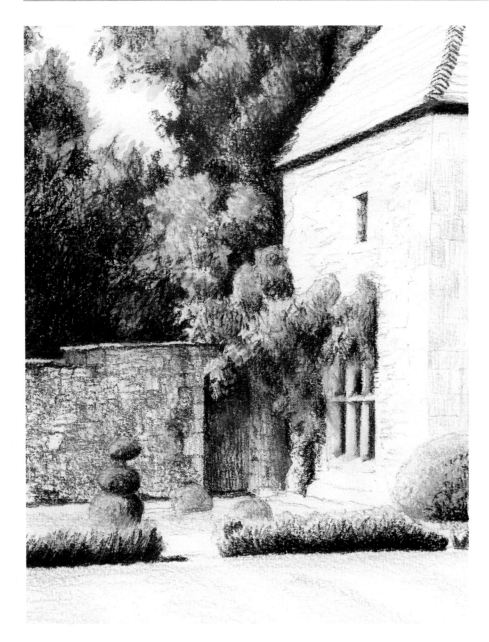

Stage 3: I then went over some of the drawing with a wet brush. As you can see it has melted the colour and consolidated many of the dark areas, filling the white speckles. I was careful not to overwork the washes of water, making sure the texture of the pencil remained visible. The window was dealt with by allowing the wetted purple of the darks to blend out into pale washes over the stone mullions of the window. I also dragged across some cool blue from the underside of the creeper by the window (see detail). The shadow side of the building was wetted and the colour smoothed to give a better density.

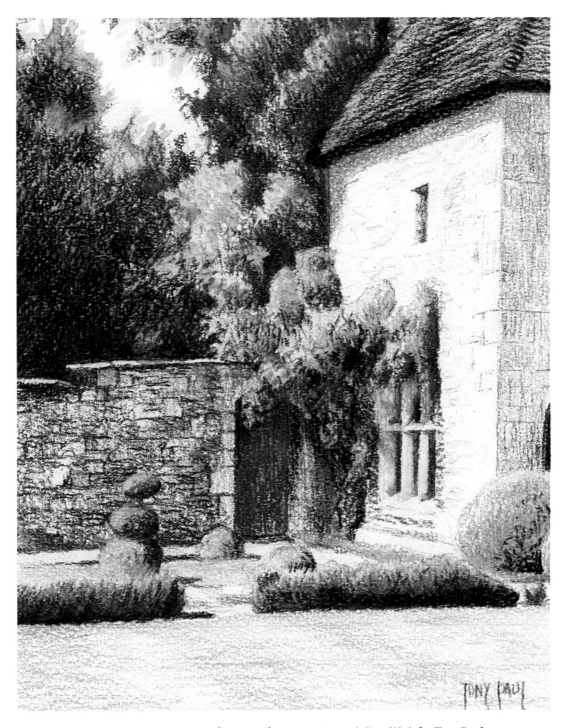

ABOVE A Corner; *watercolour pencils; 216 x 165mm (8½ x 6½in); by Tony Paul.*

Stage 4: The roof was underlaid with a burnt sienna pencil and this was brushed with water to fill the grain. It was then overlaid with various darker colours to represent the tiles. I added brown to the gate and more texture to the wall and house. The low box hedging at the edge of the lawn was coloured in, as was the brick-work around the window.

I felt that the shadow side of the house needed to be a little cooler, with the stone blockwork better defined. While doing this I was careful to make sure that the lines of the edges conformed to the perspective of the building itself. The final touches were to work generally all over the painting refining small areas.

A Coastal Scene in Watercolour by Ronald Jesty

A sun-saturated subject such as Cala Ferrera is perfect for a watercolour painting. The simplified washes, general high key, the textures – expressed in earth and other granulating colours – create the character of the rocks and sea superbly.

A sketchbook drawing was made on site in pencil. This recorded the tonal structures of the rocks, caves and the sea and included a couple of figures, which help to give the rocks a sense of scale.

Stage 1: A careful, but spare drawing was made on the stretched watercolour paper. The drawing was done firmly to make the lines show clearly and to ensure they would not be lost beneath the early washes. Then the initial wet-in-wet washes were applied loosely and only in the areas that were to be darker in tone in the final painting. Note that there is no intention to "finish off" any of the washes at this stage – they are purely the foundation washes, and will be largely overlaid later with refining watercolour work. You can see the forms of the cliffs being revealed at this stage.

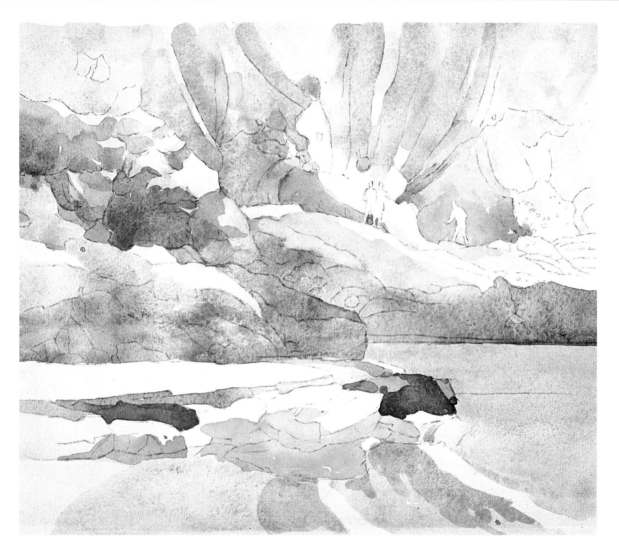

Stage 2: Cerulean blue and burnt sienna were applied to develop the modelling, particularly on the left-hand side of the painting. The washes at this stage are still structural and, although some parts of them will be visible in the finished painting, there is still no attempt to be fiddly. In the foreground a more careful approach was taken with the individual rocks, their forms being aligned to the planes of the drawing. A figure is still left as white paper (see detail).

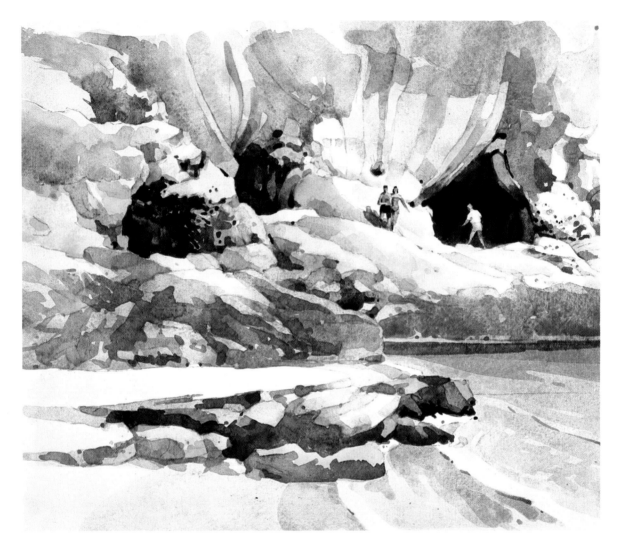

Stage 3: Much work was done to refine the image at this stage. With most of the mid-toned work completed, the next task was to punch in the darks of the caves – see how the darkening of the large cave has thrown the figure into relief. The remaining figures were coloured and further shadow work added to refine the cliffs and caves even more (see detail). A great deal of work was done to the foreground rocks – which now have a good feeling of form and variety – and to the sea and shoreline. The painting is now taking shape.

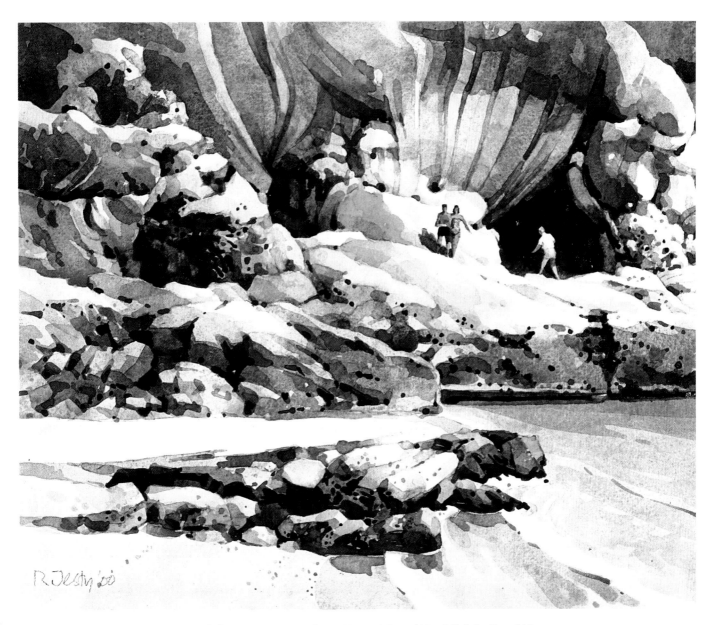

ABOVE Cala Ferrera; *watercolour; 305 x 406mm (12 x 16in); by Ronald Jesty.*

Stage 4: In this final stage planes are refined and definition given by adding small, dark accents. The dispersion of these adds texture to the rocks making them look less smooth.

A Summer Garden in Gouache by Tony Paul

Gouache – basically opaque watercolour – is an ideal medium for a subject like a summer garden. The light and colour is strong, with deep shadows. The greatest features of gouache are the ability to paint light over dark – something that cannot be achieved in watercolour – and the clean character of the colours.

The subject is a planter that sits in a corner of my garden. To me there is nothing as evocative of summer as my garden, with its colour, light and deeply shaded areas.

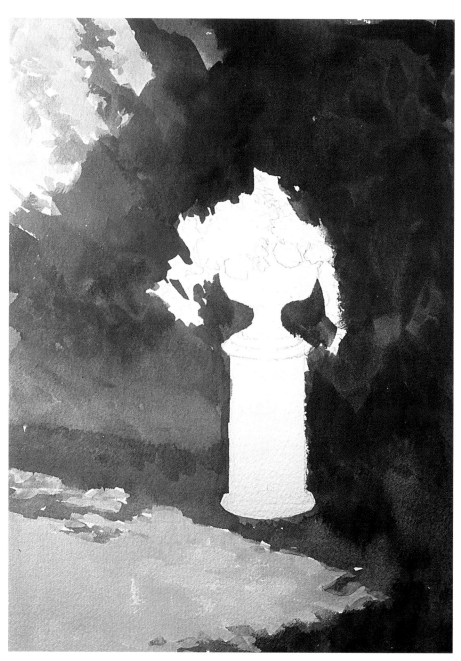

Stage 1: After drawing the subject on watercolour paper, I decided to use the overpainting technique to work from dark to light. If you look at the photo, all the greenery grows out from the dark of the foliage's shadow. It has to be remembered that dark is not usually a stark black, neither is it dead colour. Darks can be full of colour, subdued perhaps, but loaded with shaded reflected lights, which give a sense of depth. So when I blocked in the background I made it with dense, dark colours that ran into one another.

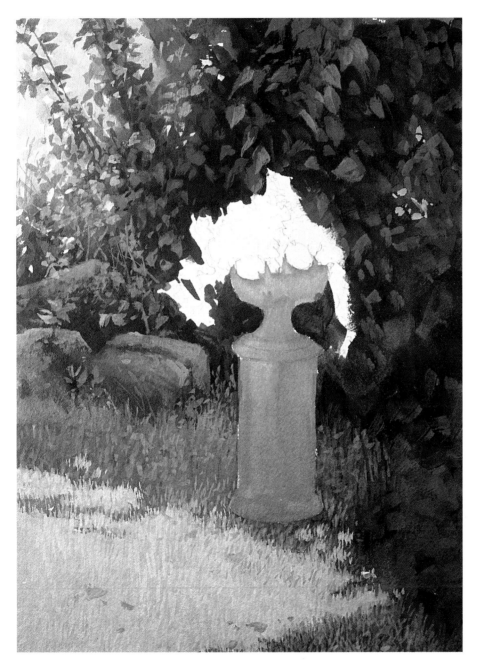

Stage 2: Mixing a cool, dark green I made random leaf shapes over the background. This is not as difficult as it may seem if you use a round brush with a good point. Just stabbing the brush into the paper will automatically give you the right shape. I used varied greens – some warmer, some cooler – and went over parts of these with a lighter colour to give a turn of the leaf. I feel that there is a sense of depth to the foliage. I developed the rocks, being careful not to make them too important and worked in both the light and shade of the grass, overlaying with small brushstrokes to imitate the texture (see detail).

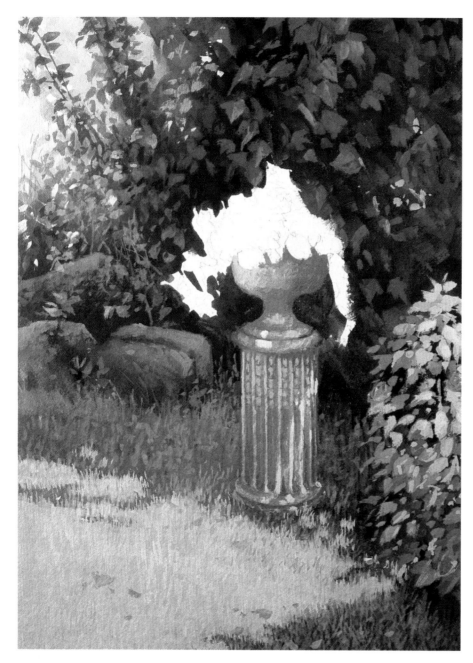

Stage 3: I next worked on the bush on the right-hand side, using greens of various tones and temperatures, but making it a little more subdued than in the photo because I didn't want such a bright area right at the edge of the painting (see detail).

The column and planter were the next items to receive my attention.

Working over the raw sienna underpainting I used dark green, a soft mid-purple and, for the highlights, white with a touch of cadmium yellow deep: pure white would have been too stark. I made sure that the planter appeared to sit in the grass.

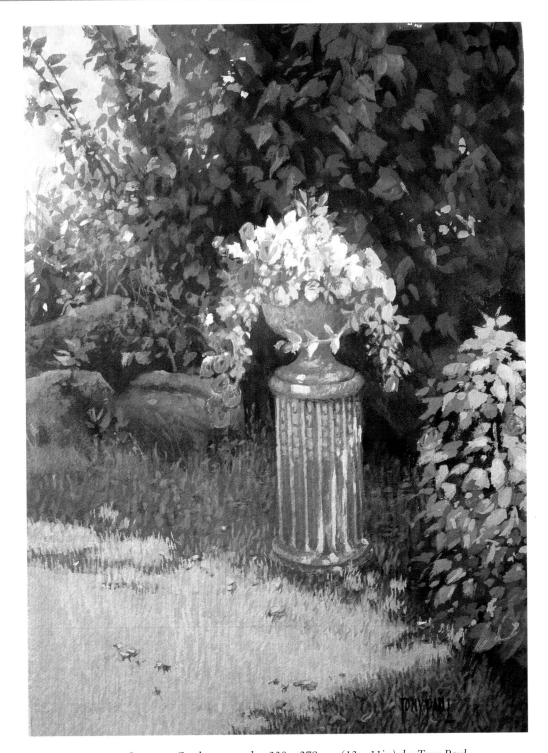

ABOVE Summer Garden; *gouache; 330 x 279mm (13 x 11in); by Tony Paul.*

Stage 4: Finally, the flowers were painted. I mixed some of the pinks, but when they dried they appeared chalky, losing a lot of vibrancy, which can happen with gouache. So I repainted them as white shapes and, when they were dry, overlaid a thin wash of the dilute red quickly so that it didn't mix with the white, but sat on top of it.

I felt that I'd lost some of the warmth of the terracotta so added small touches of orange here and there. I made sure that the foliage in the planter was of brighter greens than the background, so that it would not be confused, then went generally around the painting, refining bits such as the dry leaves on the grass.

A PORTRAIT IN EGG TEMPERA BY TONY PAUL

Purity of colour is a feature of egg tempera. It also has a textural quality that makes it ideal for a portrait. Although it does not have the tonal depth of oil I like the way that the darks can be filled with colour.

I tackled a portrait of my daughter, Lynsey, using natural light from the window. I carefully arranged the curtain behind her so that she would not be directly against the light. This had the effect of emphasizing the light from behind her, as well as on her profile. I used a very fast film for the photograph, which gave quite a grainy finish. I liked the way that the light shone through her ear and how it defined her features.

Stage 1: I didn't like Lynsey's shoulders being square on, so made them more a three-quarter view. I drew her outline fairly strongly using ultramarine blue, then overlaid this with sponged, dilute layers of red, orange, blue, green and purple. These translucent layers allowed the drawing to show through. Each layer had to dry before the next was applied. Fortunately tempera is fast-drying so this stage did not take too long.

Stage 2: My usual technique is to establish the extremes of tone in a subject. I did this using titanium white for the lightest areas and a blend of viridian and Indian red for the darks. The sponged background had a broken, almost dotty effect so I kept this theme going in the way I applied these tones.

The lights and darks, and the softened half-lights and half-darks are already bringing form to the face and there is a feeling of reflected light in the mid-toned parts of the head (see detail). Even in the hair it is easy to see the underlying contours of the head.

Stage 3: Colour, again in broken touches, was applied to the head and hair, using cadmium red, cadmium yellow, raw sienna, viridian, alizarin crimson and cerulean. The pure cadmium red used for the creases in her ear makes it seem translucent (see detail). As well as cadmium red, I used cadmium orange in the hair to catch its light.

ABOVE A Portrait; *egg tempera; 356 x 254mm (14 x 10in); by Tony Paul.*

Stage 4: I turned my attention to Lynsey's T-shirt. Using alizarin crimson, ultramarine blue, viridian and Indian red I concentrated on achieving a sense of changing light within its dark colour. My next concern was the curtain behind her. The folds and pattern were loosely defined with Indian red and viridian in various mixes. The final touch was to paint Lynsey's gold locket and the fly-away hair strands that are catching the light.

A FIGURE IN ACRYLIC BY TONY PAUL

Acrylic is one of the newer media, first brought into general artistic use in the 1950s. It was hailed as a wonder medium that would make all others obsolete, because it could be used to imitate the effects created by other media. The fact that this hasn't happened is more due to the individual strengths of other media, than any failing of acrylic.

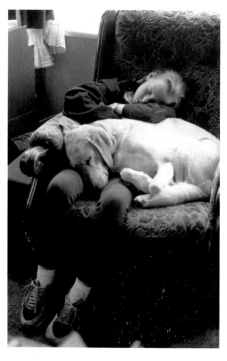

This painting features Lynsey as a young child with our dog Molly, both of whom had fallen asleep in my studio. I liked the light and felt that acrylic would be the ideal medium for the subject.

Stage 1: I made a careful pencil drawing on watercolour paper and then worked over this with a monochromatic raw umber tonal underlay applied with a flat, nylon brush. You can see the four tones in use – darks, half-darks, half-lights and lights. Acrylic is reasonably translucent and I used it as such, diluting to get paler tones and putting denser paint for the darks. I was mindful to judge tone against tone so that they read against one another clearly and created a sense of form. See how the change of direction in Lynsey's left leg is described solely by the change of tone from light to dark.

Stage 2: Using the same brush, I applied glazes of translucent colour over the tonal underpainting. I took care to use the transparent and semi-transparent colours: phthalo blue, raw sienna, raw umber and burnt sienna. This ensured that I didn't obliterate the underlying work, but blended with it to make subtle colours. You will note that I have resisted putting in any detail yet. Even the colour on Molly's head is structure (see detail). Sticking with the flat brush prevented me from getting fiddly.

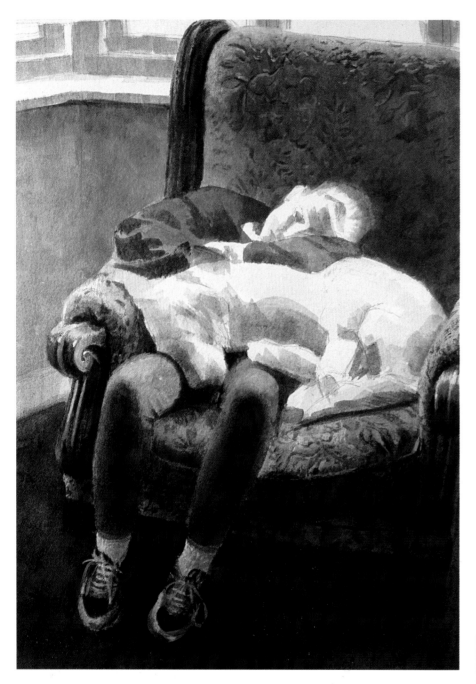

Stage 3: Taking a smaller, round brush I began to refine elements of the painting starting with the embossed upholstery fabric. I suggested a vague pattern – there is no point in copying it exactly – and then conveyed its thickness with a paler line. I worked carefully all over the chair's upholstery, noting that the cushion top was lighter in tone than the back of the chair and that the area under the cushion was warmer in hue than the greenish top and back (see detail). The carved wooden arms provided a touch of rich burnt sienna colour and, when I'd finished the chair, I began work on Lynsey's legs and shoes, keeping the colours fairly neutral and the white of her socks not too bright.

ABOVE Siesta; *acrylic; 330 x 229mm (13 x 9in); by Tony Paul.*

Stage 4: I often leave the best parts until last and now it was time to work on Molly and Lynsey. I had to look very carefully at the subtleties of tone in Molly's fur, as much of it appears more or less of one tone, the photo being slightly bleached out in the lights. Where I could see a slight change of tone I exaggerated it slightly to help with the forms. Her head was more or less there structurally, only needing details such as the eye and the modelling of the ear and nose.

I enjoyed working on the folds in Lynsey's blue top and kept the brushwork free, then turned to her head, again keeping the brushwork lively – there is always a temptation to overwork the detail. The painting was almost complete with only odd touches left to do. I added some greenery outside the windows to help define the top edge of the chair and, as a final touch, strengthened the window sill and frame.

AN INTERIOR IN OILS BY TONY PAUL

The richness of colour and effective wide tonal range make oil paint the perfect medium for this painting of a Tunisian Souk. There were several things that appealed to me in this subject. First, I liked the change of light from exterior light to interior. I loved the way that the light shone on the painted doors of the closed kiosk in the Souk and I liked the solid shape of the stocky Tunisian man. I took the shot quickly – I could see everything clearly. It would make a great subject.

When I had the slide back from the processors, I was disappointed at how dark it was. Photographic film cannot match the tones we can see and often, when using photographs of extremely tonal subjects, I have to take several, exposing first for the lights, then for the mid-tones, then for the darks. With this subject I had only one opportunity, but I felt I could make something of it with a little adjustment.

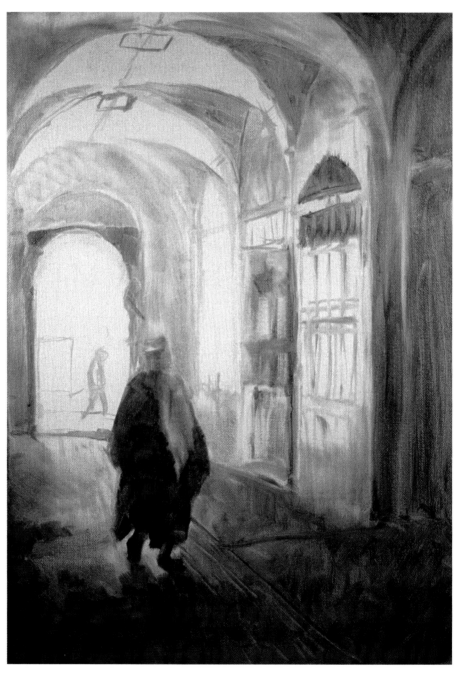

Stage 1: On a honey-tinted canvas I drew in the subject using a small brush and dilute paint. The vaulting was quite complex, so I had to be careful to get the perspective right. Having established this, I began to apply tonal areas: see how they get progressively darker the further they are away from the entrance. I roughed in the Tunisian man and already a strong sense of light is emerging, even though the work so far is considerably lighter in tone than the photograph.

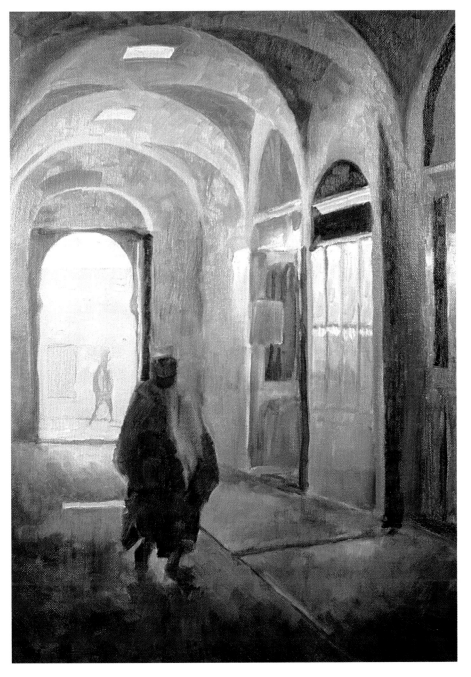

Stage 2: The first colour layer, applied when the underpainting was dry, starts to add colour to the walls (see detail). The reflections from the paintwork were put in and cooler hues added to the panelling and paving. The light shafts in the ceiling were blocked in with white and a projected light beam indicated on the ground behind the figure. We are now getting something of the tones I was seeing. The blue wall opposite the entrance was roughed in using very pale colours, leaving the passing figure and the grilled window as negative shapes of the original honey-coloured toning.

Stage 3: I put in the passing figure and blocked in the adjacent window then added the hanging lamp and the rack of red fezzes by the fez-maker's open stall. I put some time into the fan-shaped decoration above the open stall and worked carefully to refine the panelling on the nearest doors. To complete this stage, I worked on the figure: peering into the darks of the photo I lightened what I saw and carefully adjusted the man's proportions, refining his shape and making small changes (see detail).

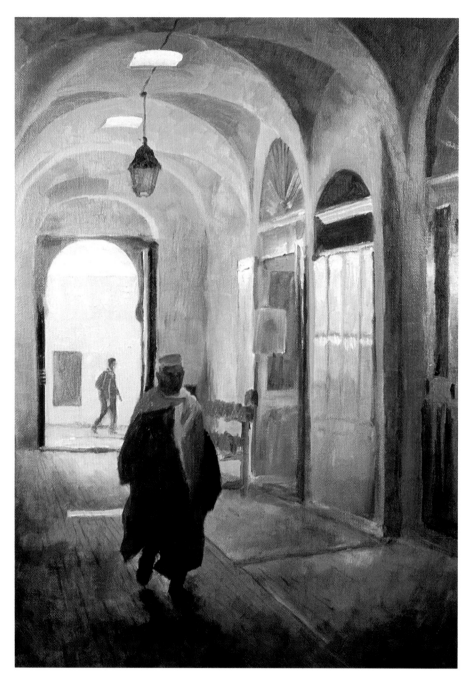

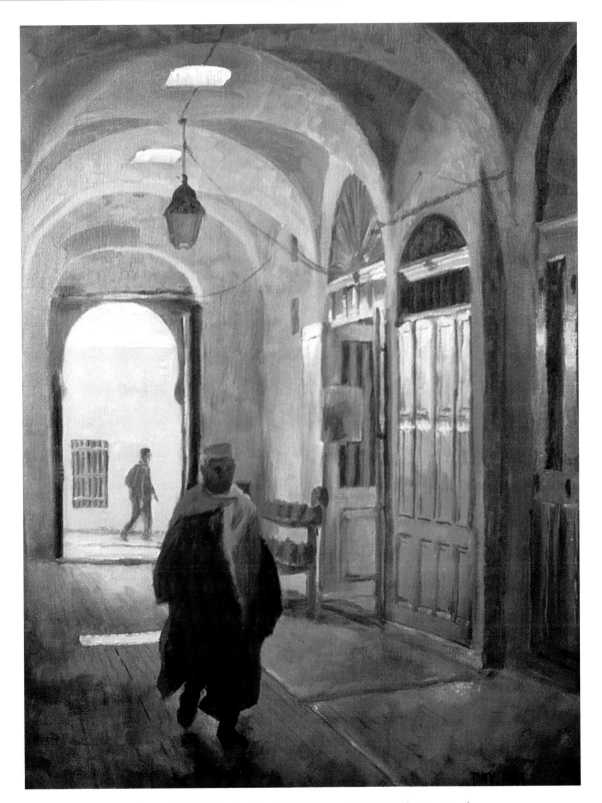

ABOVE In The Souk; *oils; 407 x 305mm (16 x 12in); by Tony Paul.*

Stage 4: I began outside by adding the grille to the window, then put a little drawing into the panelled kiosk doors. I also worked on the open kiosk of the fez maker, putting light into its interior. The final touches were to add small details like the electrical wiring and the small panels high in the far wall.

A LANDSCAPE IN PASTELS BY TONY PAUL

This landscape depicts the edge of the Majorcan hilltop village of Valldemossa, famed for its links with Chopin and George Sand. Set within the lushly vegetated terraces the aged buildings are almost swamped by cypress and olive trees. See how the low light casts interesting shadows and shows off the forms of the buildings and trees.

I thought that pastel would be the ideal medium for the subject, an opportunity to work the varied vegetation, distant hills, trees and buildings in a textural way without becoming involved with too much detailed drawing.

Stage 1: I selected a mid-toned grey-green paper with a medium tooth. My first task was to establish a reasonably accurate linear drawing of the subject. I did this using a strength of line similar to that which can be seen in the hills in the distance. Peering at the subject through half-closed eyes I judged where the darker masses had to go and put them in using a mid-grey pastel. This defined where the light and dark areas would be and began to put structure into the landscape.

Stage 2: Working from the top of the paper I first put in the sky – all the remaining tones will be judged against this, so I made sure that I didn't make it too dark. I used a pale blue and a cream of similar tone streaked into one another, and here and there a small amount of pale orange. The mountains in the background were blocked in with a medium grey and modified with blue and pink of a similar tone. A green was added to the left-hand side.

Working down, taking care to get the tonal relationships right, I blocked in the cypress trees with blends of dark grey and green, and loosely scrubbed in the lighter greens, yellows and terracottas. Already there is a sense of light in the painting.

Stage 3: Having roughed out the painting I could now begin to refine the forms in certain areas and develop the tonal relationships further. Back up in the mountains, I added greens, purples and pinks to create the impression of vegetation. I had to be careful to keep this fairly restrained – too strongly painted and the sense of perspective would be diminished. I worked on the house with the veranda, keeping it light and fairly soft so that it would sit above and behind the middle-ground buildings.

ABOVE Valldemossa; *pastel; 559 x 381mm (22 x 15in); by Tony Paul.*

Stage 4: I continued working down the painting, using different greens to create the vegetation. The wall was painted carefully to give an effect of reflected light from the ground and its shadow, a dull purple, almost complementary to the ochre of the earth. Sometimes I had to work above completed areas and I had to be mindful that I didn't smudge parts that were already completed – not as easy as it may seem when you are concentrating on the task in hand. As a finishing touch, when all the elements were completed, I worked all over the painting, touching in highlights in white and bright yellow.

GLOSSARY

ACRYLIC A quick-drying water-mixable painting medium based on acrylic resin (see page 71).

AERIAL PERSPECTIVE The effect where colours and tones soften and tend towards blue-grey as they recede into the background (see page 37).

ALIZARIN CRIMSON A popular and powerful deep purplish-red introduced into the artist's palette in 1868. Nowadays it is considered to be less than adequately lightfast. Artists are advised to use the more permanent "hue" versions.

ANGLEPOISE LAMP A type of reading light with a jointed, sprung frame that can be adjusted in both height and angle to take on almost any position. The lamp is shielded to give a directional light.

BURNT SIENNA A lightfast, reddish-brown earth pigment made by roasting the raw sienna pigment. It is a rich transparent brown and is used in all painting media.

BURNT UMBER A lightfast deep-brown earth pigment made by roasting the raw umber pigment. It is transparent and used in all painting media.

CADMIUM RED Opaque, lightfast red made in a range of hues from orangey to purplish. They work well in oil, acrylic, gouache and tempera, but are not as useful in watercolour because of their opacity, although they are often included in boxed sets. They are not used in pastels owing to toxicity regulations.

CADMIUM YELLOWS Opaque and lightfast they are made in a range from pale lemon through to rich orange. Best used in oil, acrylic, gouache and tempera, they are less useful (although used by some) in watercolour because of their opacity and, sometimes, unpredictable effects in washes.

CHARCOAL A drawing medium made from sticks of willow or vine that have been heated in sealed containers until they become charred (see page 20).

COBALT GREEN DEEP A deep green made from oxides of cobalt and zinc, the pigment is expensive and weak. It is best used for underpainting in oils, where its low-oil and fast-drying characteristics are of value. Usually found only in oil and watercolour ranges.

CERULEAN A greenish, opaque mid-blue introduced into the artist's palette by George Rowney in 1870. Made from cobalt and tin oxides, nowadays it is a very expensive, but nevertheless essential, colour in most palettes, except perhaps watercolour, where it is best replaced with manganese blue – a similar colour, but transparent.

COLOUR TEMPERATURE The warmth or coolness of a colour (see page 37).

COMPLEMENTARY COLOURS The colours that directly oppose each other in the colour wheel (see page 47).

CONTRE-JOUR Against the light – paintings made looking into the light (see page 81).

DAYLIGHT BULB Incandescant bulbs of blue glass or fluorescent strips that have been engineered to replicate the colour temperature of daylight. Useful for giving natural daylight colours to indoor subjects and, when used to illuminate the artist's work as he or she paints, prevents the cold colours that result from using ordinary light bulbs, which have a very orange cast.

EGG TEMPERA An ancient water-based medium made from pigment, egg yolk and water (see page 70).

FIXATIVE A means of "fixing" pastel, charcoal or pencil work so that it will not smudge or fall off if handled. It can also be used during the pastel-painting process to consolidate the loaded pastel surface prior to overlaying more colour.

FLAKE WHITE An opaque, flexible white, nowadays used only in oil painting. It is made from lead and so is poisonous. In my view it is still the best white for oil painting.

GOUACHE Opaque watercolour (see page 69).

HARMONIC COLOURS Colours that lie next to one another in the colour wheel (see page 44).

HUE There are two meanings. It can be used as another word for colour: "the roof was a reddish hue". Secondly it can be used to describe a colour that has been made from cheaper pigments to imitate a (usually) more expensive colour: "cadmium red (hue)" for instance.

INDIAN RED An opaque red earth pigment used in all media. It has a purplish bias, making good greys.

INDIAN YELLOW Formerly made from the urine of Indian cows it is nowadays (fortunately) a hue colour, made from synthetic pigments. Usually only seen in watercolour and oil ranges, it is transparent with a leaning towards orange.

LEMON YELLOW A pale greenish-yellow that can be made from a number of pigments, some transparent, others opaque. It makes bright greens but dull oranges.

LOCAL COLOUR The actual colour of an object under good, direct light and unaffected by shadows (see page 35).

LOST AND FOUND Where in one part of a painting the edge of a form reads strongly against another: "found", then, because of a change of tone and/or colour in the form or its background it becomes more difficult to see the edges of the form – "lost".

MEDIUM (PLURAL MEDIA) A particular type of paint – oil paint, acrylic, watercolour etc. Second meaning: a liquid that can be added to a paint to improve certain characteristics, such as impasto or gloss.

MONOCHROME One colour – usually a work in shades of grey or brown, but it can be of any colour. Always tonal. (See page 23.)

MONO-PIGMENTS Colours that are made from only one pigment, not from blends of different pigments.

OIL PAINT Made from pigments ground in a drying oil – usually linseed, but sometimes poppy, safflower or sunflower oils. It is diluted with solvents, such as turpentine. (See page 72.)

PASTEL A dry medium made from pigment moulded into sticks that are held together by a small amount of gum. Used like chalks. (See page 73.)

PHTHALO BLUE A deep, greenish-blue made from phthalocyanine. It is powerful, transparent and lightfast.

POINTILLISM The creation of an image by composing it from dots of varying tones and colours laid side by side (see page 42).

PRIMARY COLOURS Colours that cannot be mixed from other colours: reds, blues and yellows. It can also mean colours that are mono-pigments, such as viridian, which is created green, not a binary mix of blue and yellow. (See page 41.)

PRUSSIAN BLUE Discovered in Prussia in 1704 it is a very powerful, transparent greenish-blue. It is still a popular colour despite the invention of Phthalo blue (see above), which is a similar, but much better, colour.

PUTTY RUBBER A soft eraser that is less damaging to paper than harder rubbers would be. It can be moulded into shapes to take out small areas of pencil or charcoal.

RAW SIENNA A natural, brownish, semi-transparent, yellow earth colour that was literally dug from the earth and ground to a fine powder, which could then be used as a pigment. The best grades came from Tuscany in Italy or the Harz mountains in Germany. Nowadays synthetic versions are preferred, based on Mars yellow.

RAW UMBER A semi-transparent natural brown earth colour from Italy and the Eastern Mediterranean. Called "raw" to distinguish it from burnt umber (see page 122).

SATURATION The strength of a particular colour: sometimes called the chroma. The stronger the colour, the higher the degree of saturation.

SCUMBLE A veil of colour, usually paler, that is scrubbed over another colour to partially obliterate or modify it.

SECONDARY COLOUR Orange, green and purple – colours that are mixed from two primary colours (see page 41).

TEMPERATURE COUNTERPOINT The laying of a cool colour against a warmer one, or vice versa (see page 39).

TERRE VERTE Green earth: a weak, transparent grey-green, used in watercolour, oil and egg tempera. Good for underpainting flesh colours.

TERTIARY COLOURS Mixed from a secondary colour and the remaining primary colour. These are usually dull, grey or brownish. (see page 41).

TITANIUM WHITE The densest white, good for obliterating and highlighting, but can produce chalky colours in mixes.

TONAL COUNTERPOINT The placing of one tone against another to make each stand away from the other (see page 26).

TOOTH The texture of a surface. A paper with a good "tooth" will pull pigment from the pencil or pastel to make a strong mark. Surfaces with little tooth will give only weak colours/tones when used with dry media.

ULTRAMARINE Properly termed French ultramarine. A transparent, lightfast, bright deep purplish-blue, it is a mainstay of the artists' palette. Discovered in France in 1828.

VIRIDIAN An unnatural, transparent blue-green. Not used much from the tube but a wonderful mixer, giving a large range of useful greens. It has good lightfastness and can be used in all media except for acrylic, with which it is incompatible.

WATERCOLOUR A popular water-based medium, superficially easy to apply but probably the most difficult of all the painting media.

WATER-SOLUBLE COLOURED PENCILS Coloured pencils that act as normal pencils but have the added advantage that if water is brushed across the drawn image the colour melts into a wash.

CONTRIBUTORS

Richard Bell
8 Lynden Way
York YO24 4HQ
Email: ricvalbell@aol.com
York Goes Continental page 64.

Eric Bottomley
The Old Coach House
Much Marcle
Nr Ledbury
Herefordshire
HR8 2NL
www.eb-prints.co.uk
Streaks of Evening page 48,
Summer in the Forest page 62.

Gregory Davies
Crabieres
Le Bugat
Bourg de Visa
82190
France
Lavender Fields, France page 12,
Spring Trees page 31,
St Pietro, Tuscany page 40,
Canal Morning page 63,
Cows, Evening Shadows page 84.

Ronald Jesty
Flat 11 Pegasus Court
South Street
Yeovil
Somerset BA20 1ND
Maiden Castle page 76,
The Garlic Pot page 78,
Portland Bill – Looking Eastward
page 81,
The Toll House, Dusk page 89,
Cala Ferrera page 101.

Rod Jenkins
St Olave's
Fairfield Road
Blandford
Dorset
DT11 7BZ
Email: olaves@eurobell.co.uk
La Place des Martyres de la Resistance,
Aix-en-Provence page 66.

Peter Kelly RBA
The Chestnuts
The Square
Stock
Essex
CM4 9LH
Tel: 01277 840621
The White Cloth page 25,
Museum of Modern Art, Istanbul
page 28,
The Kitchen Shelf page 52,
November Morning Venice page 65,
Leaving the Bedroom page 72,
The Rehearsal page 77.

Robert Palmer RBA ROI
8 St Mary's Road
Poole
Dorset
BH15 2LH
Still Life page 45,
Windbreaks at St Ives page 83,
Still Life with Striped Jar page 88.

Linda Patterson
22 Heatherlea Road
Southbourne
Bournemouth
Dorset BH6 3HN
Email:
lindapatterson22@hotmail.com
Shadows page 40,
Rose Cluster page 73.

Tony Paul
36 Firs Glen Road
Bournemouth
Dorset BH9 2LT
Email:
tony@tonypaulart.freeserve.co.uk
All paintings unless otherwise stated.

Denis Pickles
90 Church Road
Emneth
Wisbech
Cambridgeshire
PE14 8AF
Email: Denis25334@aol.com
Back Road, Essex,
Massachussetts page 61.

George Thompson ATD NDD
2 Hilbre Court
South Parade
West Kirby
Wirral
CH48 3JU
Tel: 0151 625 2478
Mykanos, Greece page 46,
Delphi, Greece page 61,
Old Dee Bridge, Winter page 62,
Northgate Street, Chester page 64,
Barcelona Café page 68,
Tuscan Landscape page 71,
Elterwater and Langdale Pikes page 73,
Venice Waterfront page 74,
Bridge Street, Chester page 83,
St Mark's Square, Venice page 85.

ACKNOWLEDGEMENTS

I would like to thank the following for their help in the production of this book: Rosemary Wilkinson and Clare Hubbard of New Holland who gave valuable advice and encouragement and to the designer Ian Sandom who has made such a good job of giving the book "eye appeal".

My grateful thanks go to the very talented artists: Richard Bell, Eric Bottomley, Gregory Davies, Ronald Jesty, Rod Jenkins, Peter Kelly, Robert Palmer, Linda Patterson, Denis Pickles and George Thompson, who have allowed their work to be used in the book; to Richard Cartwright for saying such nice things in the foreword; to Hedley Lacey Bsc (Opth) Hons., M.C.Optom, who guided me through the technicalities of light and human vision; to John Harrison, who helped with finding a good selection of tapestries; and to Daler-Rowney whose paints I used for all my paintings. As for my family, my love and grateful thanks to my daughters Sally, Kerry, Julie and Lynsey, who modelled so well for me and, lastly, thanks to my wife Rae, for putting the light in my life.

INDEX

INDEX

INDEX